QUILT
ARTISTRY

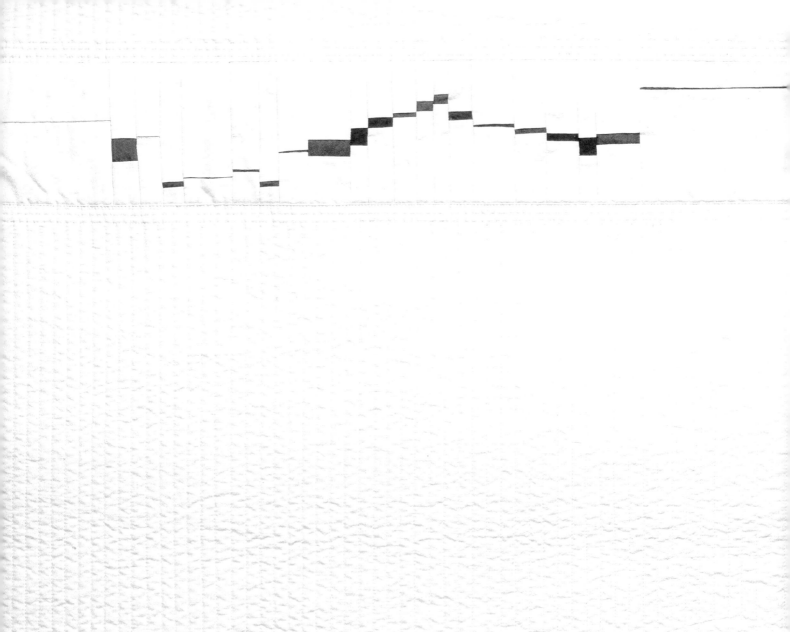

QUILT ARTISTRY

INSPIRED DESIGNS
FROM THE EAST

YOSHIKO JINZENJI

KODANSHA INTERNATIONAL
Tokyo • New York • London

TRANSLATED BY
JULIET WINTERS CARPENTER

NOTE FROM THE PUBLISHER:
These quilts were actually made using metric sizes, and the imperial conversions given may not always be exactly equivalent.

Distributed in the United States by Kodansha America, Inc., 575 Lexington Avenue, New York, N.Y. 10022, and in the United Kingdom and continental Europe by Kodansha Europe Ltd., 95 Aldwych, London WC2B 4JF.

Published by Kodansha International Ltd., 17-14, Otowa 1-chome, Bunkyo-ku, Tokyo 112-8652, and Kodansha America, Inc.

First edition, 2002
ISBN 4-7700-2756-7
02 03 04 05 06 07 08 09 10 10 9 8 7 6 5 4 3 2 1

Library of Congress CIP data available

www.thejapanpage.com

Baby Quilts. Bamboo-dyed silk. ▶

CONTENTS

Foreword by Jun'ichi Arai 6

Introduction 8

PART 1
Quilts Made from Antique Cloth and New Textiles

My Quilting Journey 25

Some Japanese Quilting and Patchwork Traditions 30

Small Modern Amish Quilts 34

Mandalas Made from Precious Cloth 38

Transparent Quilt: "Watermark" 46

Shimmering Cushions 50

Lampung Embroidery 54

Spiral Block Quilt: "Versification II" 58

 Spiral Block Cushions

 African Spiral Cushions

Optical Quilt: "Star Connection" 62

PART 2
Quilts Made from Fabric or Fibers I Dyed Myself

Grass House Studio 67

 Ketupat Braided Offerings

The Discovery of Bamboo Dyeing 71

Embossed Quilt: "White Repose" 74

 Braided and Woven Table Mat

Silk Ribbon Hammock 78

Ornamented Cushions 82

Baby Quilts 86

Natural Dyes and Quilting 90

 Indigo Dyeing in Bali 93

Engineered Quilt: "Grass Wind" 94

Engineered Quilt: "Coconut Field" 98

"Color" 102

"Dew II" 106

"Sound" 110

Beginnings 114

Additional Designs, Patterns and Instructions 115

Acknowledgments 126

Photo Credits 126

Glossary 127

Index 128

FOREWORD

Yoshiko Jinzenji's life is marked by discipline. Her freedom is a freedom of the will, and her creations are reflections of the way she lives. The high artistry of her quilts derives from freedom employed within the bounds of a rigorous discipline.

Her quilts are simple and to the point. They contain no foolish chattering. They are magnetic, with an appeal that is strongly sensuous. Open your heart to them and they will induce a delicious intoxication.

The quilts she makes are never uneven. The slightest variation in technique becomes a mirror image, inverting and about-facing again and again as it continues to chant the endless rhythms of life. The quilts beckon us to a world of wide-open spaces that are bounded by a fierce passion held in check. There we wander idly, finding not only joy and elation but also whispers of grief and lamentation, perhaps even low cries of despair.

I associate Yoshiko's work with the world of the primitive. We (I take the liberty of speaking for others as well as myself) revere primitive work. Things created by nameless artists let out their voices, singing vigorously of life and revealing to us a world of calm and ease. Such works are universally beloved. The spirit of their makers takes them over and dwells in them, living on and on.

Works of concentrated strength and seeming artlessness have a spirit of impromptu prayer that draws on the energy of nature. Impromptu creations can come about only through such prayer. There is no greater power on earth than that of prayer invested with the whole heart and mind and strength. Such prayer is life itself.

The best primitive works are brimming with life, radiant with youth. They have an unassuming strength, peace and freshness. They are ever new, as if brought into being only yesterday, yet lacking the sense of peril in things of today. Yoshiko's work has undergone many stages of evolution, while always remaining fresh and original. Her work shows the power of her tenacious will. Like primitive peoples, she embraces materials that lie near at hand, along with

the tools to match them. Out of those natural juxtapositions are born new discoveries that go on fostering new creations.

Fashion authorities were unanimous in calling Yoshiko's discovery of bamboo-dyed white a tremendously difficult technical and creative feat. The application of bamboo dye to almost any fabric gives it a beautiful, completely new complexion. When I was shown that even fibers of type 66 nylon film could take on a gorgeous flesh tone, I felt I had been made witness to a kind of twentieth-century magic.

In this way, Yoshiko's secret processes have opened up new realms of the unknown and unseen. Her world is like the paradoxical world of the primitive—springing from the bowels of the earth and connecting our lives with the people who lived before us and those who will come after.

In choosing to use innovative contemporary synthetics at times and at other times to weave and even dye her own cloth herself, Yoshiko has set a new aesthetic standard as a quiltmaker and a maker of cloth.

What is it, I wonder, that anchors and sustains Yoshiko, free-floating spirit that she is? At a temple in the ancient capital of Nara I witnessed the uninhibited freedom and stillness—the serenity—of her flower arrangements. Viewing them was like sipping fragrant tea before a piece of calligraphy by a master, or reveling in the simple goodness and sheer delight of a home-cooked meal.

I am convinced that Yoshiko Jinzenji's achievements in establishing a new genre in quilting will never be forgotten.

—JUN'ICHI ARAI
Textile Designer

Embossed Quilt: "White Repose." Bamboo-dyed silk. 84 ⅝ x 102 ⅜ in. (215 x 260 cm).

I N T R O D U C T I O N

For me, quilting and natural dyeing are complementary elements in the same act of transforming cloth.

The quilts that initially inspired me to begin quilting, and that continue to fascinate me, are antique Amish and Mennonite works. After I began quilting about thirty years ago, I traveled many times to Indonesia, eventually establishing my studio there, and at one point I encountered the Indonesian *selendang*, a striking traditional shawl that very much resembled the Amish quilts that I already loved.

I wondered what it was that these two forms had in common, since the *selendang* is not quilted or pieced, and then I realized that they both were dyed with natural dye. This drove home to me the power of dyeing cloth with natural materials.

Quilting, dyeing, and the combinations of textures in the cloth itself—all are elements that alter the surface of cloth, adding shadows and shapes that reflect light in different ways, and creating a pleasing rhythm of alternating tension and relaxation.

In addition to natural dyeing, I have often made quilts from the extremely innovative synthetic materials made by Jun'ichi Arai, one of Japan's best-known textile designers. In any case, no matter what the material, what I am striving for is to bring out and add to the essential textures of the cloth, to create shadows and light, and to find a balance between minimalism and a sense of richness.

My work has always been a natural progression from one interest to the next—one adventure or experiment after another—and this book is basically a record of that adventure.

I have received so much inspiration from traditions that arose outside Japan—primarily from the quilting of North America and also from Asian dyeing and weaving traditions. I hope that by publishing this introduction to my work in English I can give back to the quilting world a little bit of what I have received.

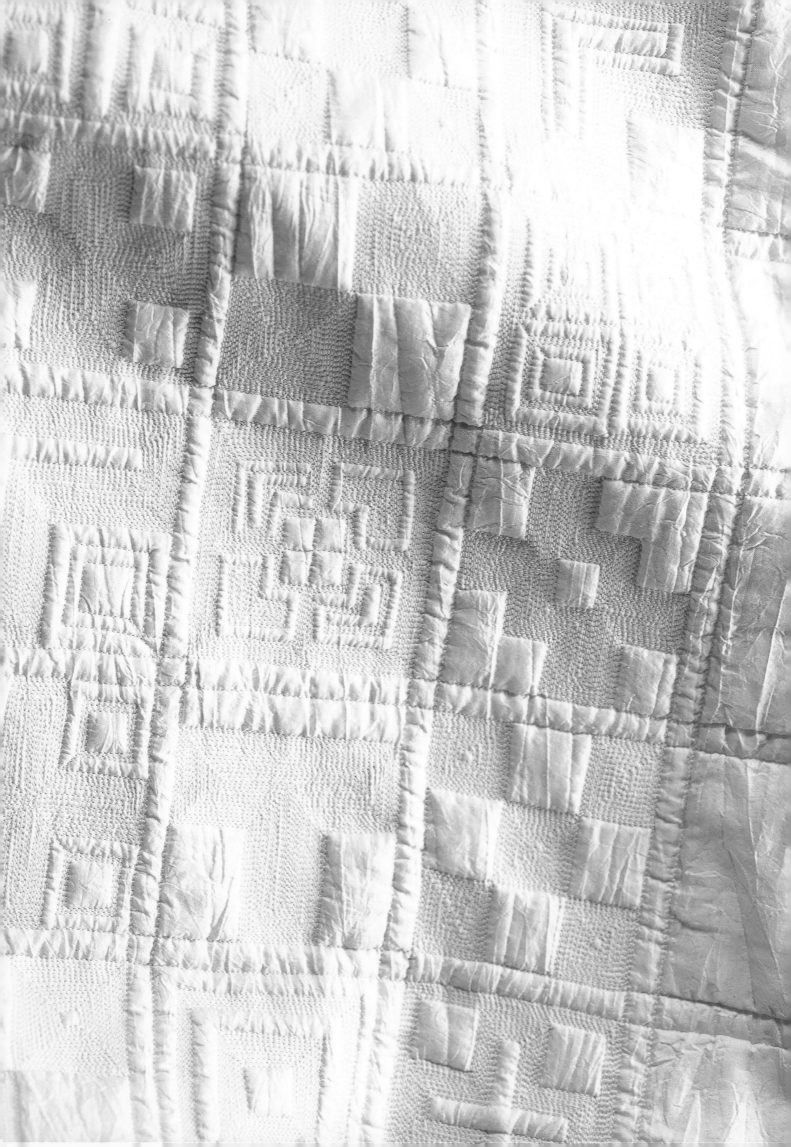

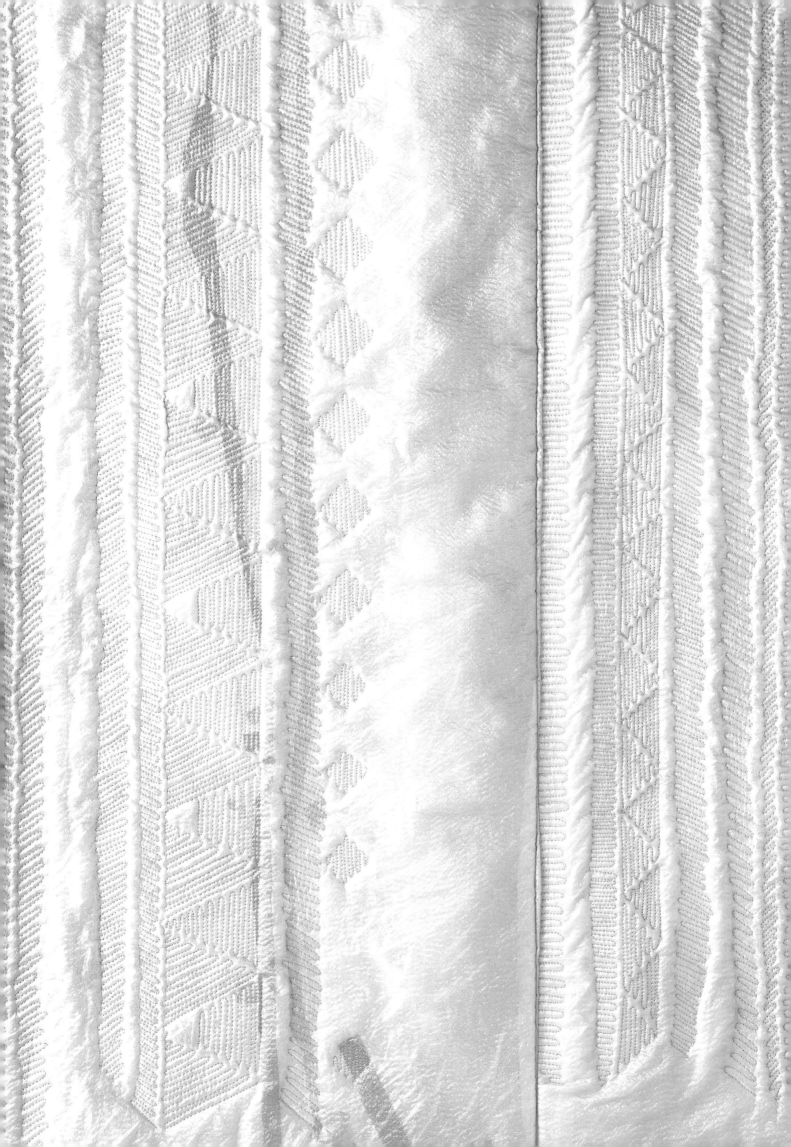

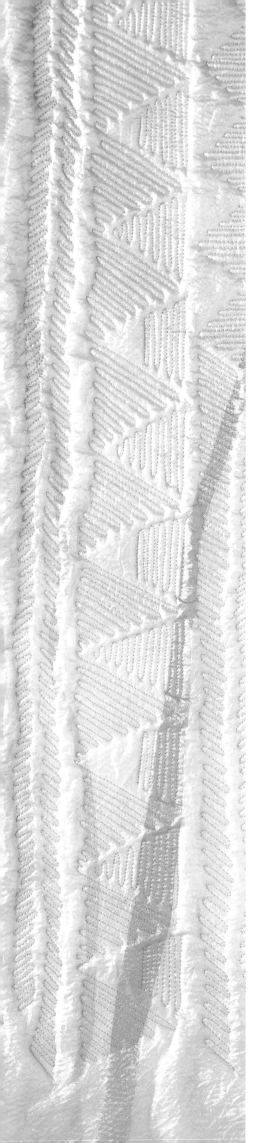

Optical Quilt: "Shimmering Waves." Nylon dyed with natural dyes, aluminum-coated nylon, aluminum-coated polyester, bamboo-dyed silk. 77 ¼ x 78 ¾ in. (196 x 200 cm).

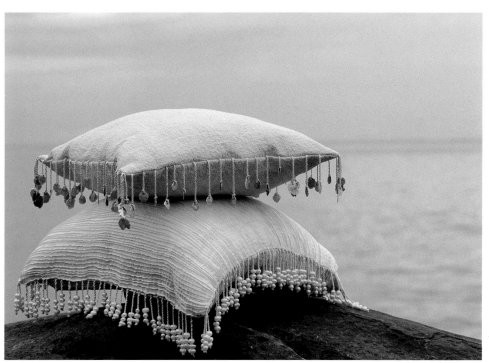

Ornamented Cushions. Bamboo-dyed silk, silver, pearls.

FOLLOWING PAGES: "Ten Thousand–Piece Quilt." Ten thousand scraps of cotton fabric dyed with natural dyes. 72 ⅞ in. (185 cm) square.

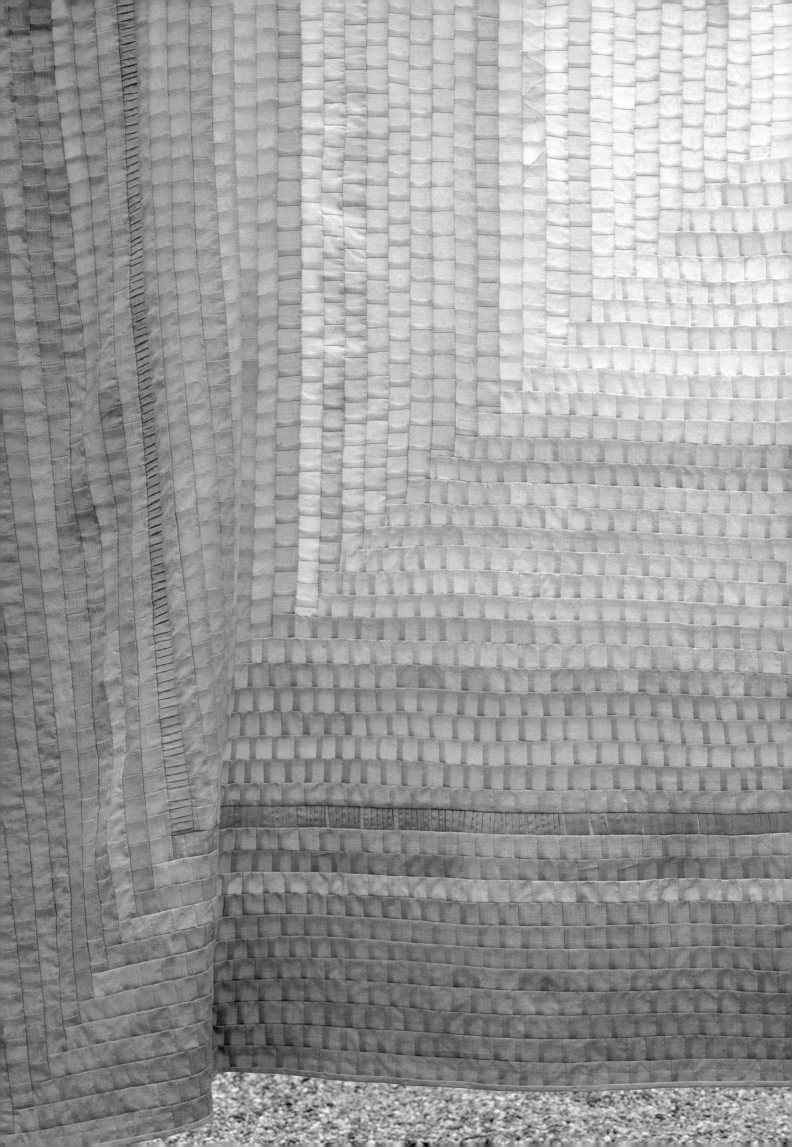

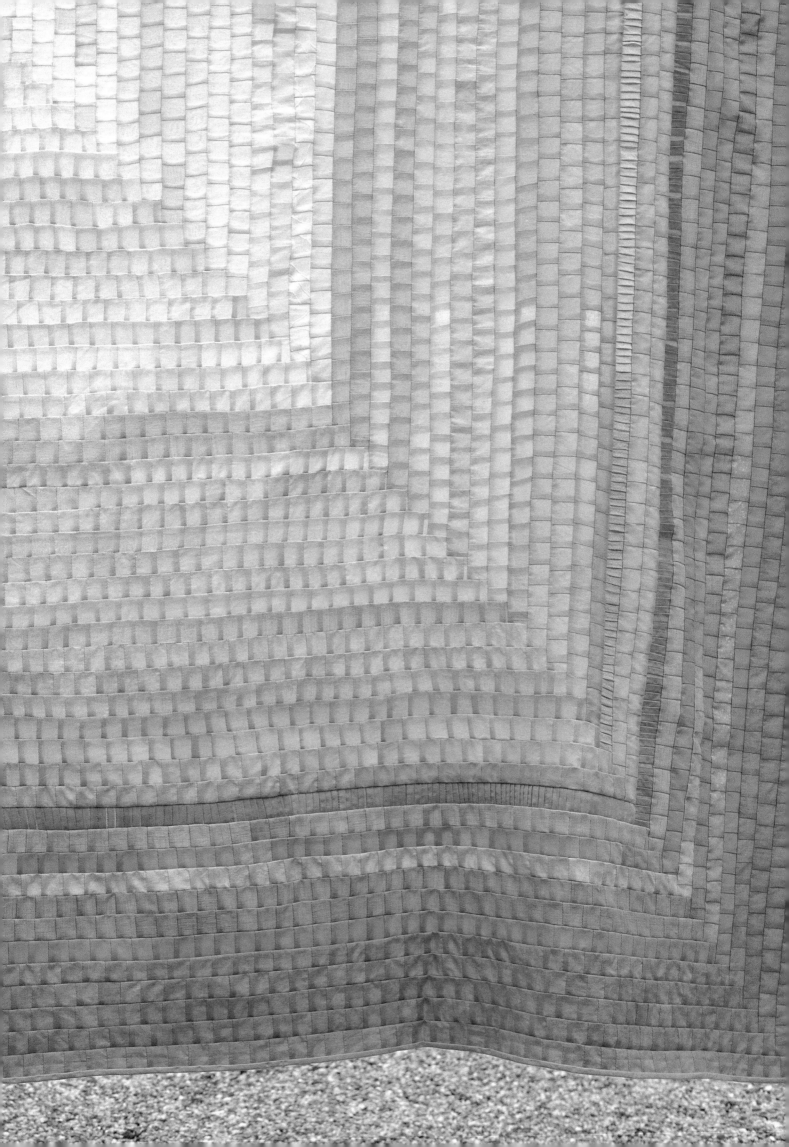

"Bamboo White." Bamboo-dyed silk. 83 $\frac{1}{2}$ x 93 in. (212 x 236 cm).

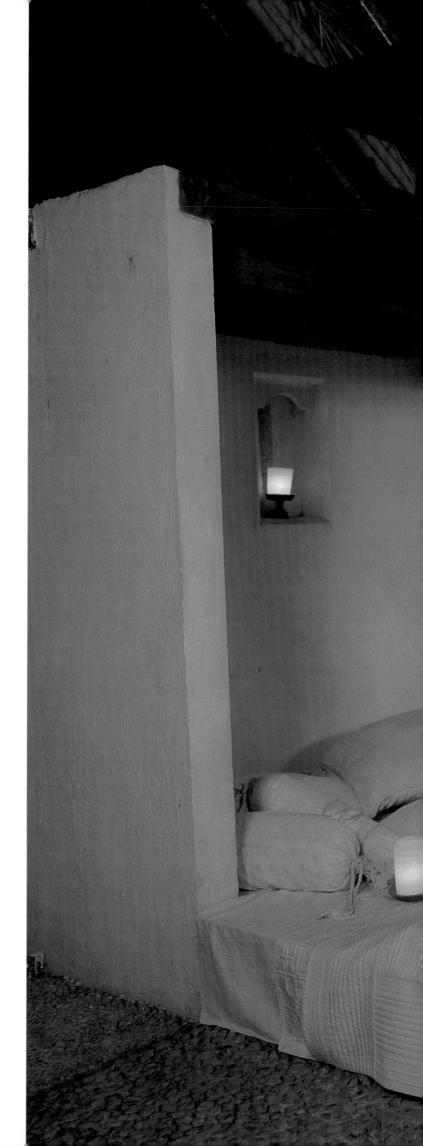

FOLLOWING PAGES: Many of my small Mandala quilts placed together as if they were one quilt.

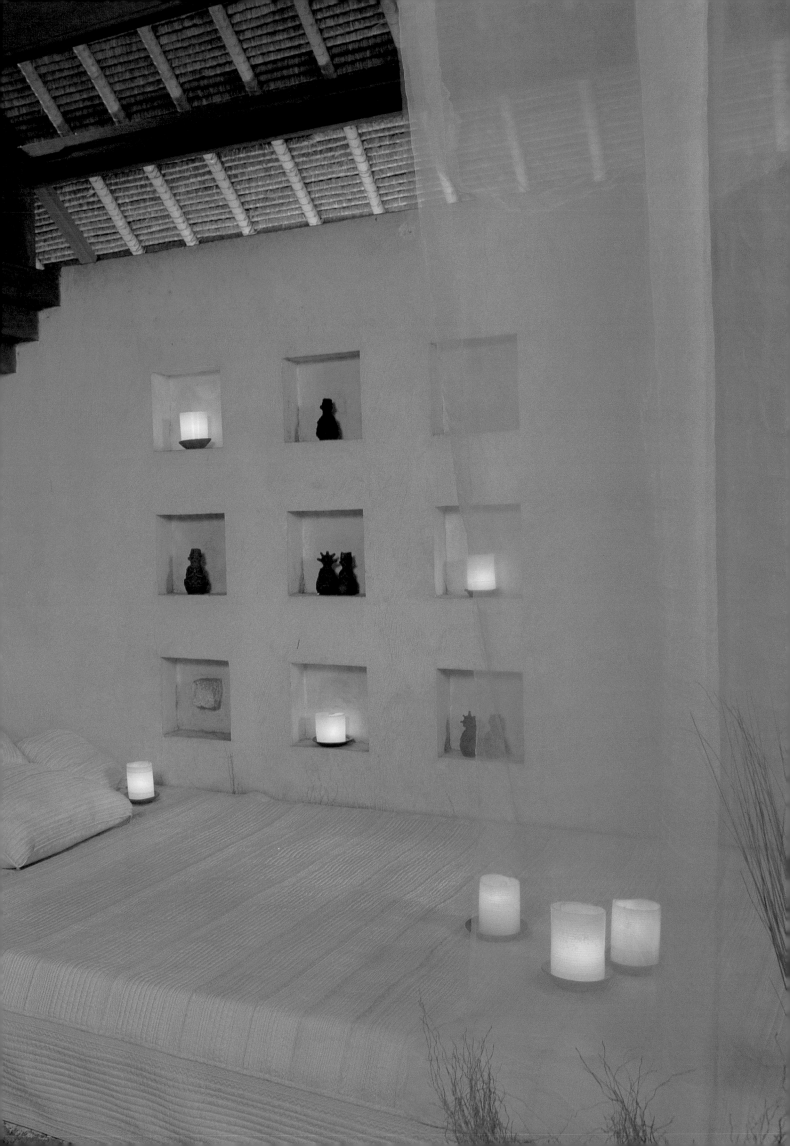

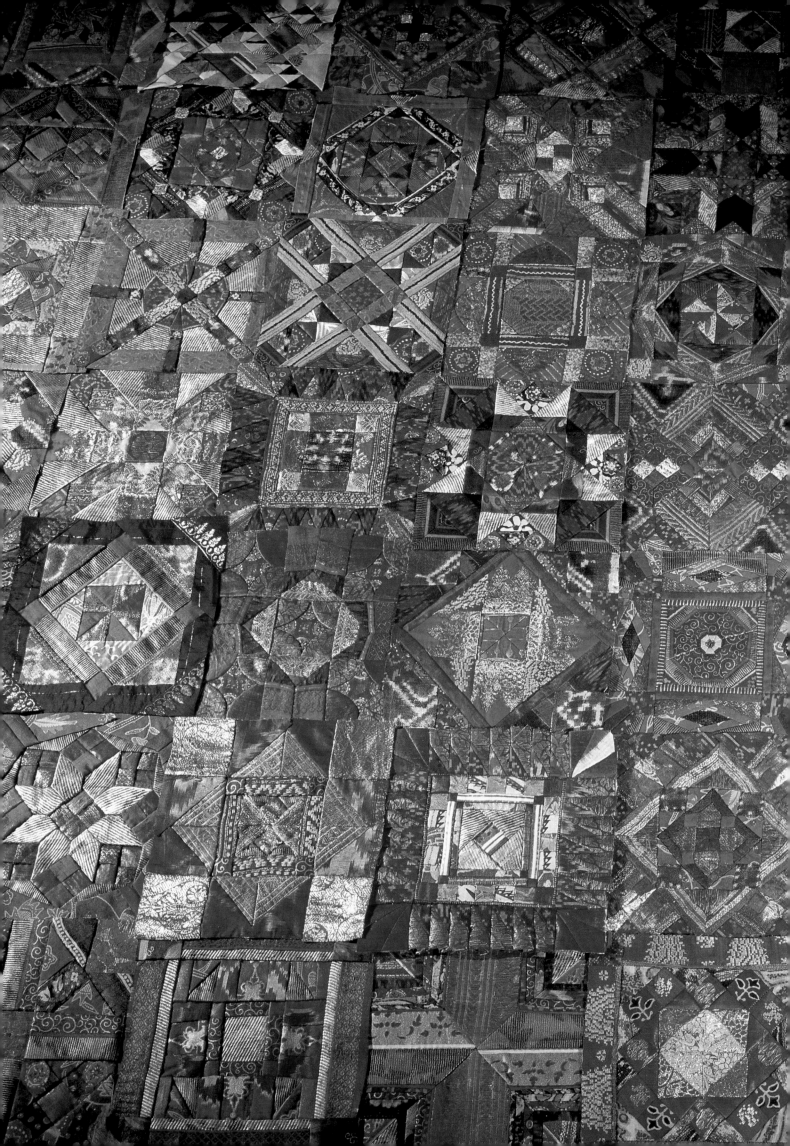

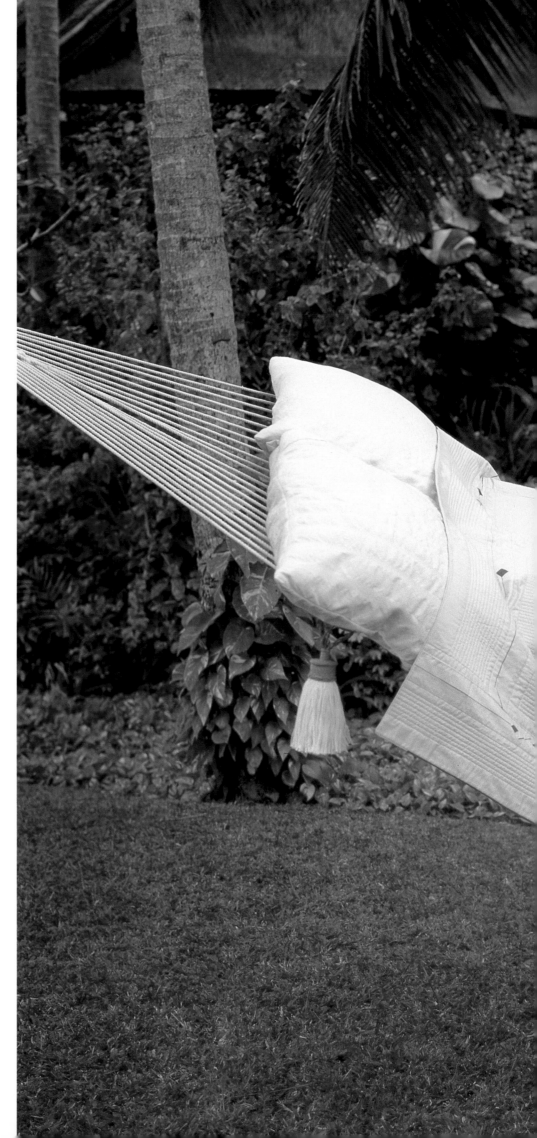

"Dew I." Silk and cotton dyed with bamboo, and wool and silk dyed with natural dyes. 72 ½ x 73 ⅝ in. (184 x 187 cm).

FOLLOWING PAGES: Spiral Block Quilt: "Versification II." Silk, wool, cotton, nylon, polyester, rayon, cupra, titanic oxide–coated nylon, synthetic rubber. 59 x 98 ½ in. (150 x 250 cm).

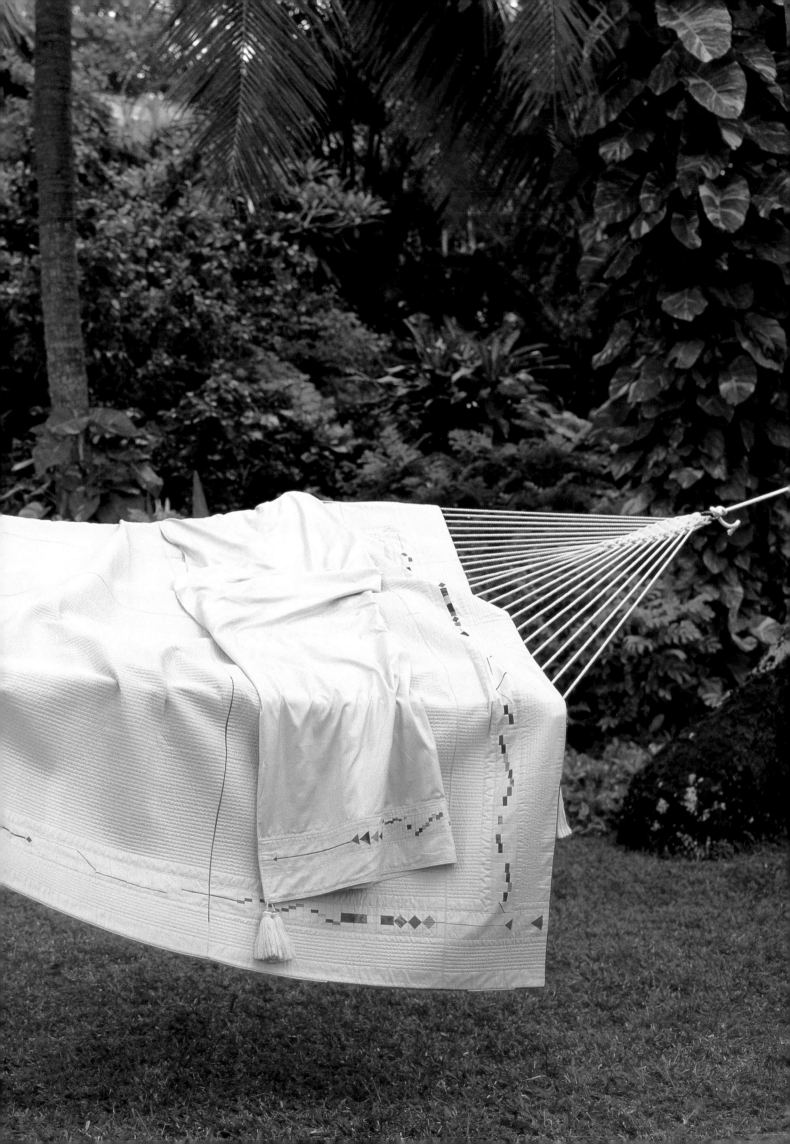

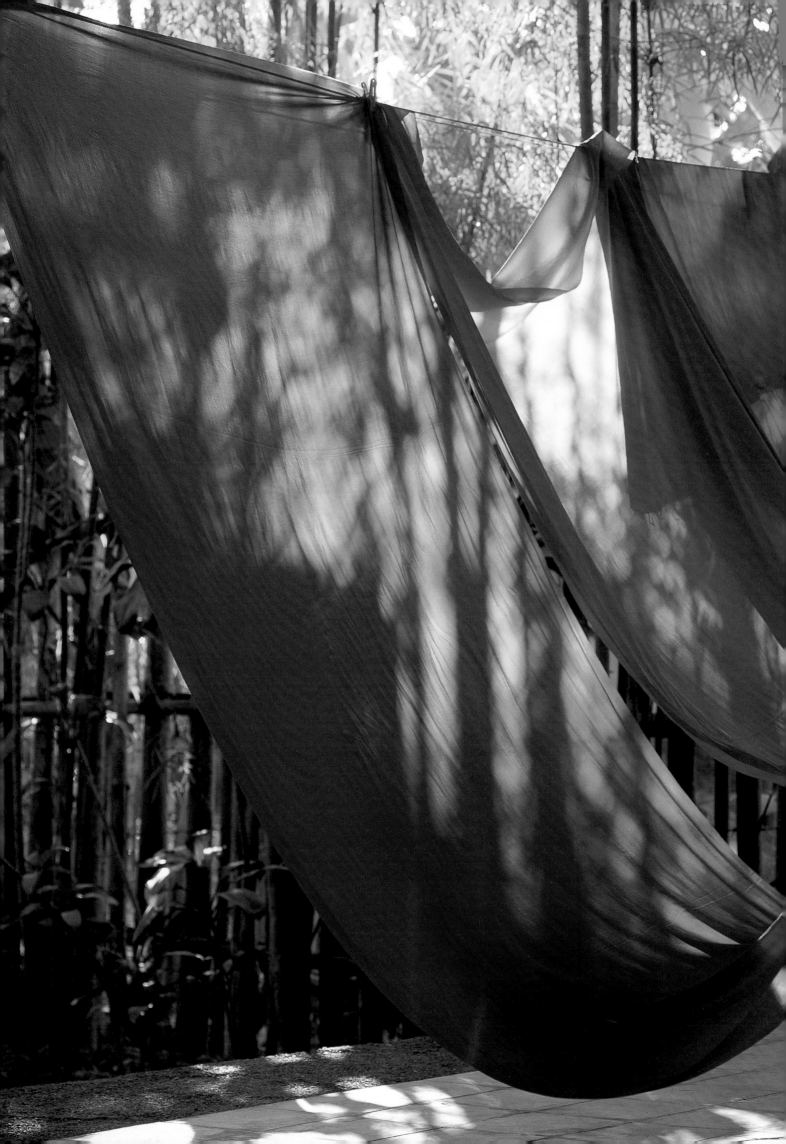

Silk dyed with tropical dyes, hanging outside my studio.

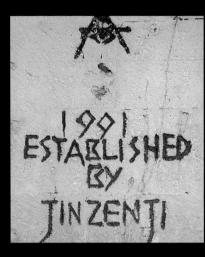

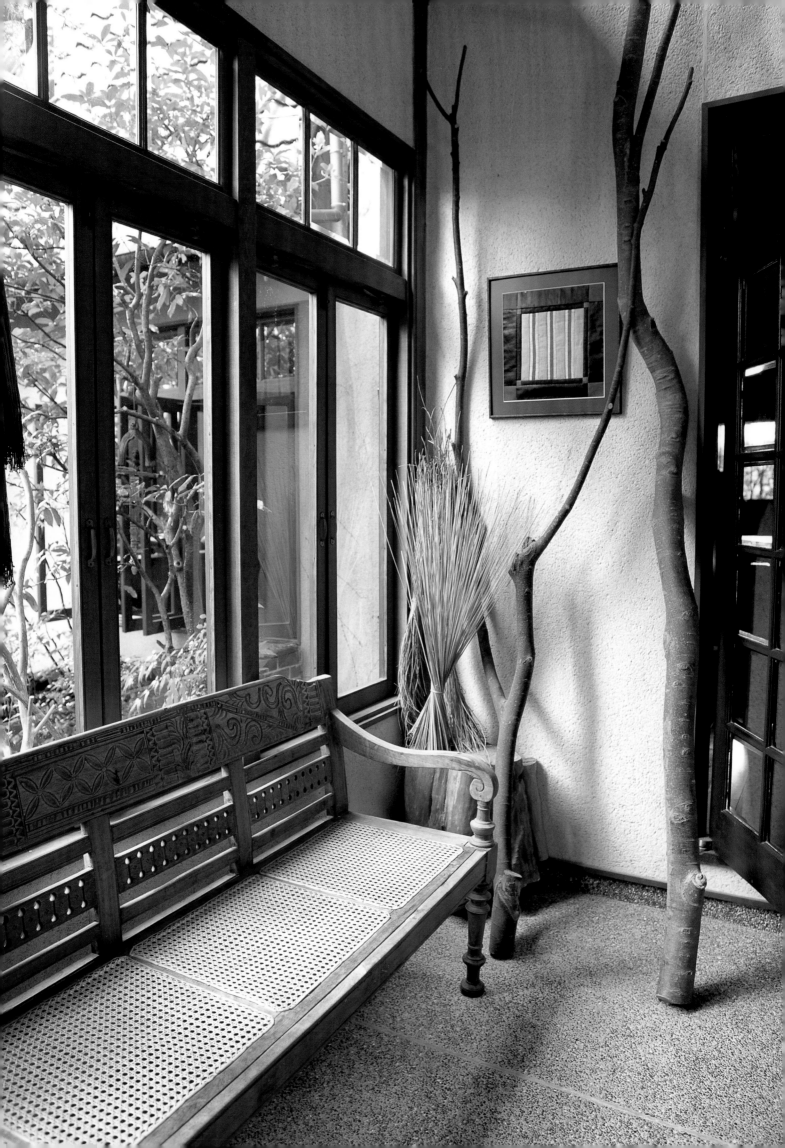

QUILTS MADE FROM ANTIQUE CLOTH AND NEW TEXTILES

My Quilting Journey

I have a very clear memory of my first encounter with quilts. It was in Toronto in the winter of 1970, in the furniture section of Eaton's department store downtown. There, surrounded by standardized fluffy bedspreads, were two handmade quilts draped over wooden racks. I went over to them as if drawn by a magnet and took them in my hand, wondering what on earth these handmade quilts were doing in the middle of a display of manufactured goods. The oddity of the combination was stunning. The quilts were made by joining together many small pieces of cloth and then covering the whole with fine hand stitching. Each had a price tag, and I was stunned again to see that they were not much more expensive than the manufactured spreads. Who could have made these, I asked myself, and what had inspired their beautiful handwork? The riddle of the quilts' existence made them endlessly fascinating to me and the search for answers became all-consuming.

I soon found out that they had been made by women of the Mennonite community of Waterloo County, dozens of miles west of Toronto. On weekend expeditions, little by little I became acquainted with the religious community of men and women who dressed in simple black clothes and traveled in horse-drawn buggies (later my quest would also take me to the Amish people of Lancaster County, Pennsylvania). Every chance I got, I would set off early in the morning to visit the Farmers' Market that was run by the Mennonite people, where I would get some of their fresh-picked sweet corn. In early spring I went to the Maple Sugar Festival and saw steam rising from huge vats of sap being boiled down and many other old-time sights.

One of my Small Modern Amish quilts displayed on the wall of my house in Kyoto.

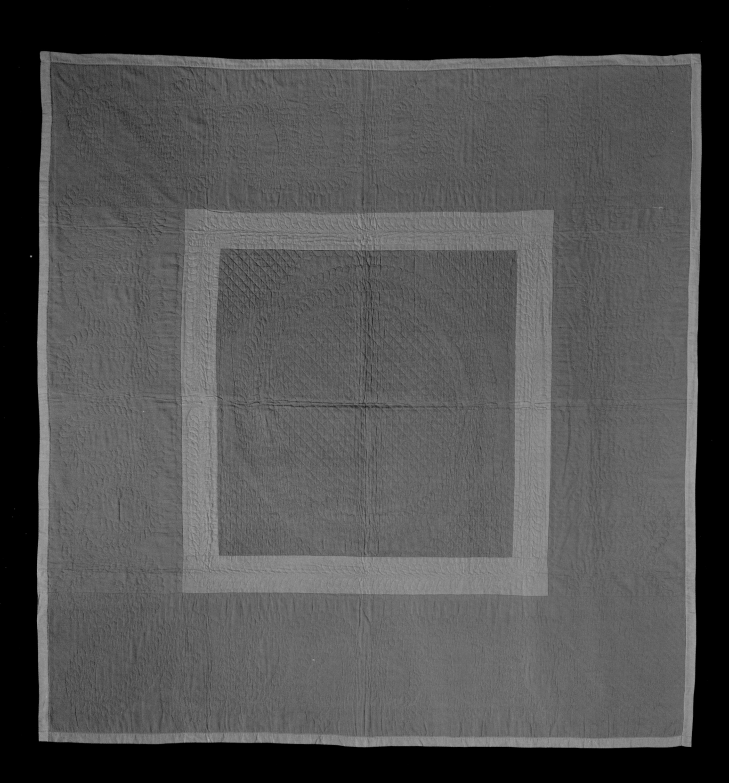

Center Square. Pieced wools. Unknown Amish quiltmaker, Lancaster County,
Pennsylvania, circa 1890. 77 in. (195.5 cm) square. Esprit Quilt Collection
of Doug Tompkins of San Francisco, California.

Antique Canadian quilt, Ontario. Wool, handspun, home-dyed, handwoven. 76 ¾ x 74 ¾ in. (195 x 189 cm). Textile Museum of Canada.

And there were always hand-stitched quilts on display that I could touch and examine. Quilts made by women of the community were entered in the Relief Sale, while others went on auction all over the region. I learned that the history of Mennonite relief efforts had included shipping vast quantities of powdered milk and wheat to Japan after World War II, some of which had been used in school lunches when I was a little girl. The discovery of such an unsuspected personal link to the Mennonite community was deeply moving.

The donation of proceeds from the auction of Mennonite and Amish quilts for assistance and relief programs around the world gives the community quiltmaker a role of global significance. I realized that the world of women's handwork was making a huge contribution to the welfare of humanity, and that helped inspire my eventual decision to devote my own life to quilting. At the same time I learned that Amish quilts were now being recognized and sought after by museums and private collectors as modern art. That is because their simplicity and understated beauty appeal directly to the human heart.

I was awestruck by the power I found in the quilts, as if they were tremendous wedges driven into the modern world to preserve what is most basic and wholesome in the human spirit. The natural dyes from the second half of the nineteenth century, the handwoven wool, the bold two-toned patterns, tranquil yet strong; the unique color composition and above all the deeply religious spirit—all of it was a revelation. I set out to study on my own the message that women inscribed in North American history, using their needles to piece together the stories of their lives.

I became determined to unravel secrets of the craft from every angle. I visited antique markets to buy old quilts that I then took apart to investigate the stitching, binding and materials, and lingered in museums to study designs and simply to look. Then in 1979 the Ontario Crafts Council awarded its Provincial Prize to my work, "Star Quilt," saying that they had singled it out for its inventive use of color. That was very encouraging, since it seemed to confirm my own sense that the best way for me to develop creatively was to focus on combinations of colors and combinations of materials.

I began to feel strongly that I needed to learn more about materials, and particularly about the indigenous dyeing culture of my own country. I returned to Japan after more than ten years in Canada, to find out all I could. My interest centered on kimono—the traditional costume of Japan—and I began using kimono fabric in quilts of my own design. In fact, my interest in

kimono was of long standing, since my grandmother, my mother and I were all accustomed to wearing that style of clothing in daily life; from age nine to twenty-three I'd studied flower arranging and tea ceremony, both traditional pastimes where the old kimono culture survives intact. I soon realized that my long familiarity with the garment—accustomed as I was from an early age to the feel of it against my skin—had nurtured in me an instinctive ability to select the finest kimono material.

In the course of things I began to teach classes in quilting. The art of quilting was a catalyst allowing large numbers of women to develop interests outside the home and to share the joy of making things as we all learned together. The classes reminded me of the value of many things: patience with the elderly, encouragement, friendships that could grow out of classroom situations, harmony in interpersonal relationships. At the same time I felt a keen sense of responsibility as I tried to guide others in their creative endeavors.

Meeting textile planner Jun'ichi Arai was another seminal experience for me. I was very taken with his contemporary fabrics, which while using impossibly innovative technology still capture something of the human soul. His skillful application of cutting-edge technology makes possible the creation of textures that could once have been made only by hand. Touching Mr. Arai's creations made me realize anew how indispensable fine fabric is to the world of quilting. Inspired by the many extraordinary fabrics he invented, I began to broaden my concept of quilting. It seemed to me that making quilts with these very contemporary fabrics—particularly quilts that were based on established patterns—could be a way to honor and even highlight the essence of the traditional forms, by combining them with innovative synthetic fabrics. Working with Mr. Arai's textiles, though, demands the use of a sewing machine, since they can have such wildly varying textures. I began to conceive of machine-stitched quilts as another valid form of expression in the craft.

A *kembangan*, which is one type of *selendang*. Shibori with natural dye on silk. 33½ x 78¾ in. (85 x 200 cm). Sumatra. Author's collection.

Just at that time, various new possibilities opened up, thanks to the influence of my family. My father-in-law, a professor of art education, encouraged students in Japan and Indonesia to visit one another's countries, and I soon began traveling there as well. In 1983 I held my first quilt exhibition in the Indonesian capital of Jakarta, and from then on I traveled back and forth many times between that country and my own, steadily educating myself about Asian dyeing and doing fieldwork. My studies led me into many new paths, and the more I learned, the more solid my grasp of the whole became.

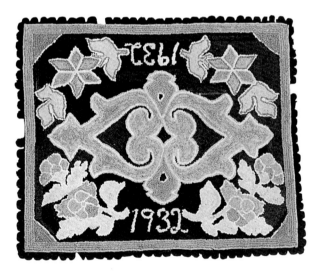

Amish hooked rug, 1932.
Author's collection.

Once I was traveling through Sumatra—another part of Indonesia—and was in the old capital of Palembang when I suddenly came upon a traditional shawl, or *selendang*. The strong emotion I had felt in Canada on encountering Amish quilts seized me again. Quilts and *selendang*: one is from the northern hemisphere and the other from the south, and each in its way is the epitome of beauty and embodies high spiritual ideals. My admiration for their colors led me to learn all about natural dyes, to see whether I could reproduce the amazing colors of either Amish quilts or *selendang*. Gradually my desires took concrete shape, materializing as the Studio Grass House on the Indonesian island of Bali, which became the place where I could pursue my creative goals.

Along the perimeter of a triangle connecting points in North America, Japan and on the equator, I came up with one hypothesis after another and tested them all myself, going back to the basics.

As a little girl, the arts of flower arranging and tea ceremony absorbed me until I was transplanted to North America in midlife and got to know quilting there. Now, decades later, I found myself again in dialogue with plants, extracting their essence and using it to dye thread, then weaving the thread into cloth with which I make my quilt creations. My long childhood familiarity with flower arrangement did come to have a large role in my life, after all.

The cloth and the quilts you make are in the end a representation of your life. My quilting journey has been one of constant discovery. It has been a means of exploring what it is to be alive.

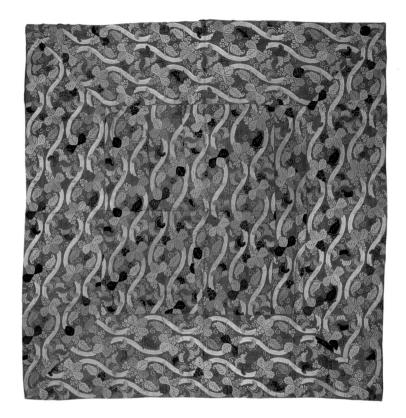

Uchishiki altar cloth of silk brocade with a pattern of bold undulating vertical lines and large paulownias. It was made by taking apart a kimono and resewing it into a square shape; in this process all the material of the kimono was used, with none left over. Dated 1607. 69¼ x 68¾ in. (176 x 174.5 cm). Kodaiji temple.

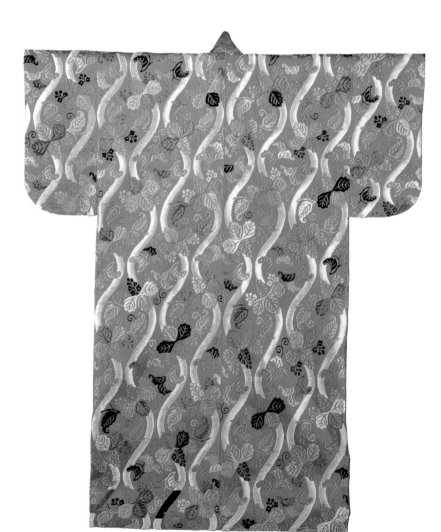

Reproduction of the *uchishiki* altar cloth shown above, which has been restored to a kimono shape. Using the less faded parts of the original as a guide, an attempt was made to reproduce the original colors with vegetable dyes. 1994. Nagai Orimono.

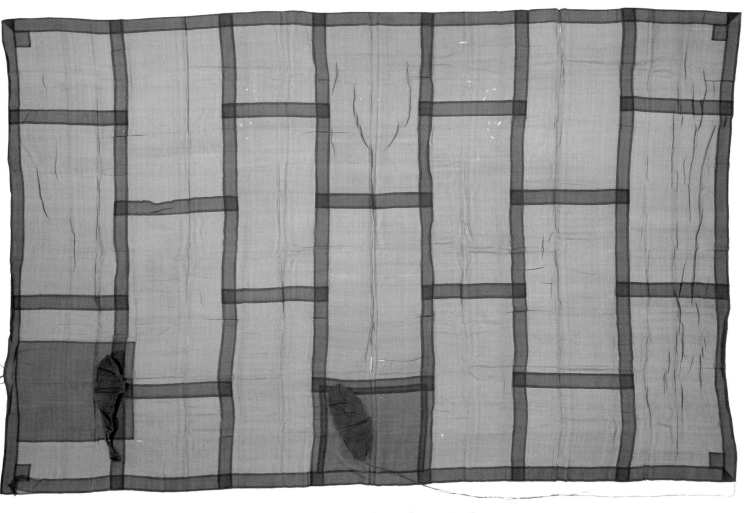

Silk *kesa* surplice owned by the priest Chiko (709–770). Gangoji temple.

The tradition of quilting has never been nearly as strong in Japan as in the West, but we do have several long-established quilting traditions.

The best known of these is no doubt *sashiko*. The cold northern regions of Japan boast beautiful traditions of *sashiko* stitching, which is still popular today. Since the climate was too cold for cotton, hemp was cultivated instead. Linen cloth was dyed with indigo and fashioned into kimono and work clothes. Layers of indigo-dyed linen were stitched together with precious white cotton thread, providing extra warmth and reinforcement as well as decoration. Family love and pride motivated women to create beautiful patterns that made the articles not just useful but also appealing.

There are also several less well-known forms of quilting that were traditionally done in Japan and that are associated with Buddhism. Quilting was done to make the type of priest's surplice known as a *funzoe* (rag patchwork) that was layered and quilted. The *funzoe* was thought to embody important Buddhist teachings. It was made from scraps of old clothes donated by parishioners. The monks would gather the rags, wash and cut them, then layer the

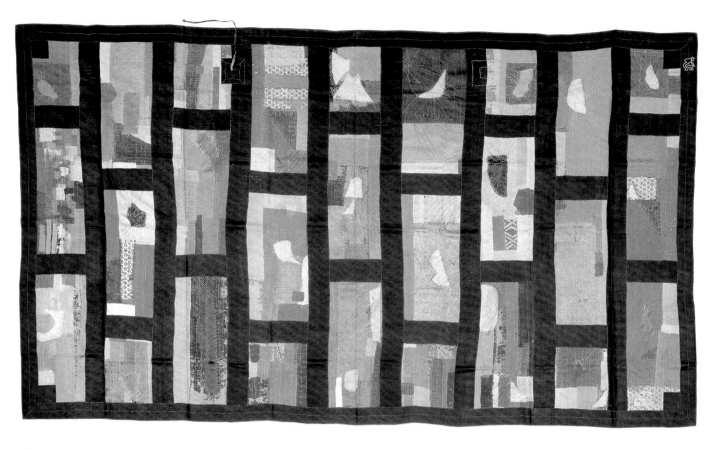

Funzoe owned by the priest Jiun Onko (1718–1804). Kokiji temple.

the pieces and put in beautiful stitchwork over the entire surface. The surplice was worn hanging diagonally from the shoulder, over a monk's robe, and it had two religious meanings. First, retrieving the rags from the dustbin and allowing them to end up in a place of honor signified that the cloth itself attained Buddhahood. Second, the practice suggested the interconnectedness of all human beings.

The surplice was always stitched together from narrow strips of cloth, three at a time. Three cloth strips sewn together formed a unit called a *jo*, which would then be patched together to form the finished product. A surplice might contain anywhere from five *jo* to twenty-five, invariably in odd numbers. (Odd numbers have traditionally been valued in Asian thought for their stubborn indivisibility, representing that which cannot be easily explained away in life or the universe.)

Another tradition involved making one large, square patchwork altar cloth by taking apart a single kimono. The sleeves and other parts of the kimono were let out and reattached to the body to form a perfect square, without wasting any part. Kodaiji temple in Kyoto has a large seventeenth-century collection of these colorful altar cloths, or *uchishiki*, made from kimono of brocaded or embroidered silk donated by upper-class women of the time (see page 30, top). These four-hundred-year-old cloths—eloquent testimony to the faith and devotion of the women whose bodies they once adorned—are spread on altar tables before Buddhist statues, with Buddhist implements and offerings placed on top of them.

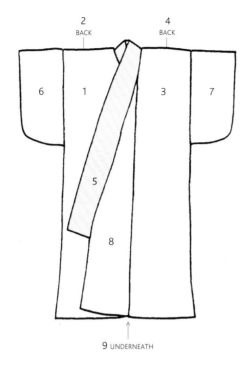

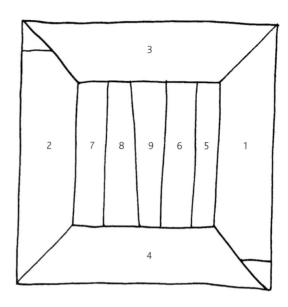

Reassembling the kimono as a square.

1 Body (right, front)
2 Body (right, back)
3 Body (left, front)
4 Body (left, back)
5 Collar

6 Right sleeve
7 Left sleeve
8 Top overlapping front panel
9 Bottom overlapping front panel

In recent years, researchers have restored some *uchishiki* to their original kimono shape (see page 30, bottom). This made it easier to visualize how the two-dimensional cloth would have looked as clothing. Since most of the fabric was shifted to different positions when a kimono was transformed into an *uchishiki*, the overall patterns of the two forms could be very different.

The illustration above shows how a kimono can be reassembled as a square. The center of the square here is made up of the collar, sleeves, neck, and the overlapping front panels. The right and left halves of the body of the kimono, front and back, make up the four outer sides enclosing the center.

The ingenious way that the kimono is made attests to the respect Japanese have traditionally had for cloth. It is made from a roll of fabric 14 inches (36 centimeters) wide and 12 yards (11 meters) long; the straight pieces of the garment are cut from the roll so that all the material is used, with no waste. It was this idea that inspired me to try to make Engineered Quilts (see pages 94–101), where the entire work is planned with the final design in mind from the time that I dye and weave the fibers by hand.

I have been inspired by all kinds of traditions—Amish, Buddhist—and in fact have antique quilts from North America and Asia in my mind as a kind of standard. I hope to bring together in my work some elements of the traditions that have inspired me and also to add a new style of expression that is my own.

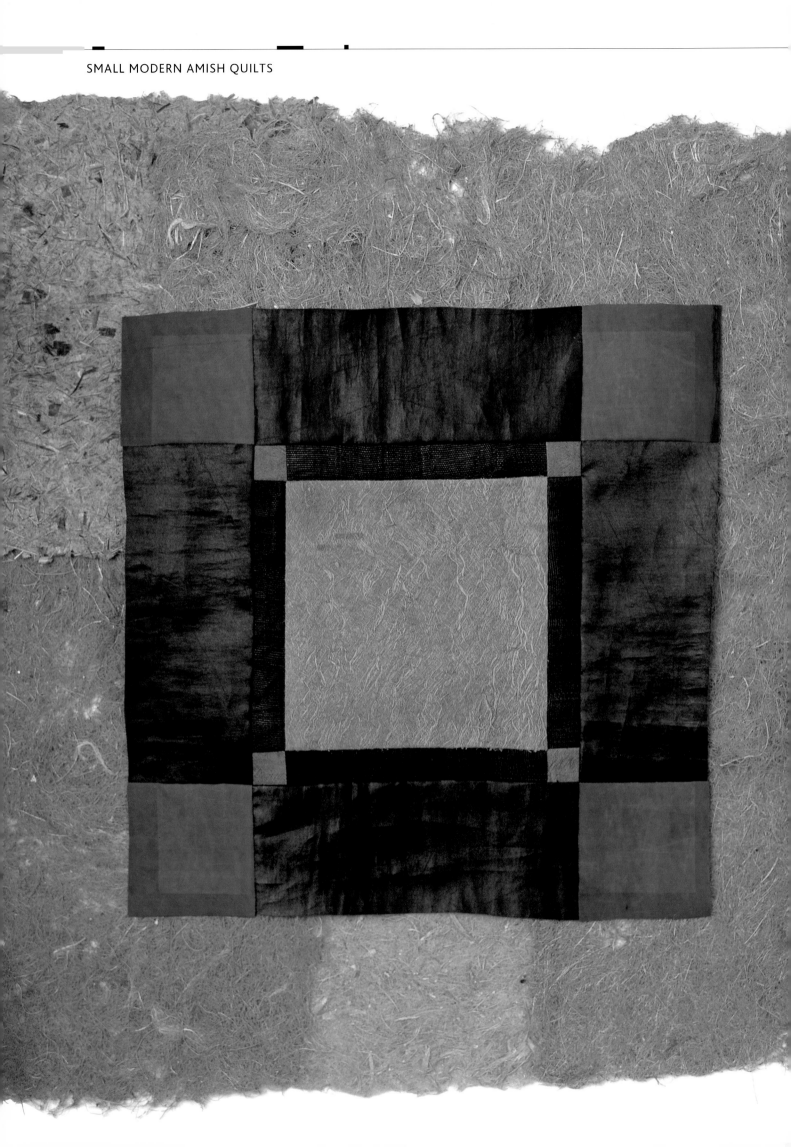

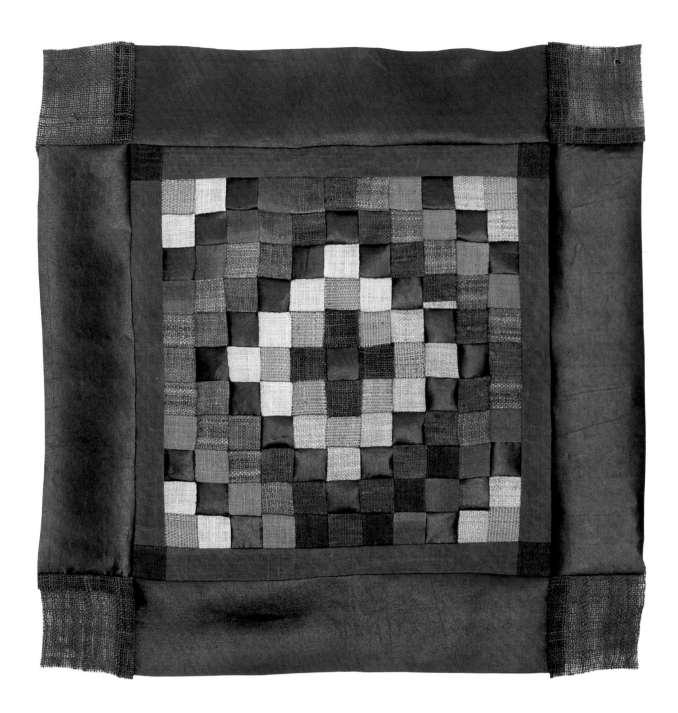

The Small Modern Amish series, of cloth from throughout Asia.
FAR LEFT: Black lacquered silk, brown lacquered silk, *tapa* and *abaca*.
ABOVE: Black lacquered silk, silk kimono fabric, cotton, linen and
ulap doyo. LEFT: Black lacquered silk, brown lacquered silk, *tapa*,
abaca, *shifu* (woven paper cloth) and *shina* cloth (woven from the
fiber of the Japanese *shina* tree).

KEY

Silk (black lacquered)

Silk (brown lacquered)

Tapa (Kalimantan [Indonesia], yellow-brown)

Abaca (the Philippines)

Tapa (Africa, red-brown) **MORE DESIGNS CAN BE FOUND ON P. 115.**

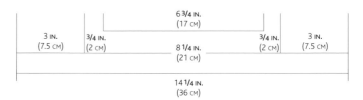

3 IN.
(7.5 CM)

3/4 IN.
(2 CM)

6 3/4 IN.
(17 CM)

8 1/4 IN.
(21 CM)

3/4 IN.
(2 CM)

3 IN.
(7.5 CM)

14 1/4 IN.
(36 CM)

These are made from natural fibers with a rich variety of textures: *tapa* mulberry bark cloth, *abaca* banana leaf-stalk cloth, Indonesian *ulap doyo*, Japanese *shina* cloth, *shifu* (woven paper cloth), wisteria cloth, linen, homespun cotton and lacquered silk. Each has its own feeling—glossy or flat, smooth or rough, hard or soft, stiff or pliant, heavy or light, thick or sheer, sharp or dull, cold or warm. I make a mental chart of the effects of different combinations—considering the balance, contrast, and volume—and select the ones that speak to me. In quilt design, color and shape are perhaps the most directly expressive elements, but it is texture that really brings these elements to life.

For years I had collected all-natural fabrics everywhere I went, even before I had any idea how I would use them. Then at one point I discovered some black lacquered silk made by a Chinese ethnic minority. I mixed it with other native fabrics and was able to use the striking textural contrast in creations of my own.

To show off the quality of the material to best effect, I selected the austere simplicity of Amish quilt patterns. I used this lacquered silk, which has a deep glossy sheen, as the base cloth, alternating between areas of the front and back (black and brown, respectively). Then I set many other native fabrics with different kinds of textures against this background.

Each finished work is small—barely 14 ¼ inches (36 centimeters) square—but powerful. Framed, these make delightful interior decorations (see page 24).

If you make sturdy handmade paper from the fibers of plants and rest one of these small quilts on it or use it as a frame, the paper's softness draws out the unique textures of the fabric.

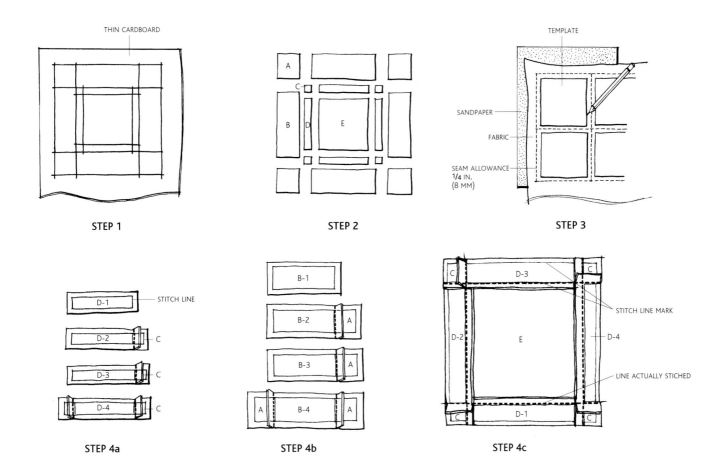

STEP 1 **STEP 2** **STEP 3**

STEP 4a STEP 4b STEP 4c

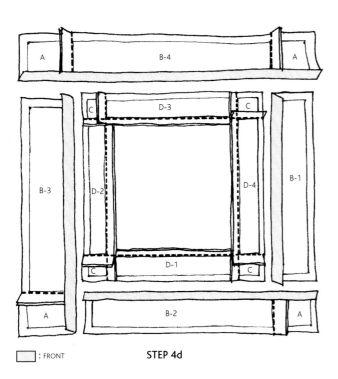

☐ : FRONT **STEP 4d**

TECHNIQUE: Machine piecing
COMPLETED SIZE: 14 ¼ in. (36 cm) square

STEP 1: Draw the template patterns in actual size on thin cardboard and cut them out.

STEP 2: Label the templates A, B, C, D and E as shown.

STEP 3: To cut the fabric, place a template on top of the fabric (right side of the fabric down) and trace around it with a sharp B or 2B pencil. Putting a piece of sandpaper beneath the fabric will help hold it in place. Leave a seam allowance of ¼ in. (8 mm). Leave ⅝ in. (1.6 cm) open between each template. Cut out 4 each of A, B, C and D, plus one of E, for a total of 17.

STEP 4a: First, as in the illustration, place C and D together (right sides facing), secure with a pin, and stitch together. Then fold the seam down towards C. (After folding a seam down, always press it with an iron.)

STEP 4b: Repeat with A and B, folding the seam down towards A.

STEP 4c: Attach the group from Step 4a to the center, E. First sew on D-1, and fold the seam down towards E. Do the same for D-2, D-3 and D-4.

STEP 4d: Attach the group from Step 4b to 4c, beginning with B-l. Fold the seam down towards B. Do the same for B-2, B-3 and B-4.

NOTE: It's best to use a sewing machine to join the fabric patches, since they will have different textures and thicknesses. And be sure to put in a backstitch at the beginning and end.

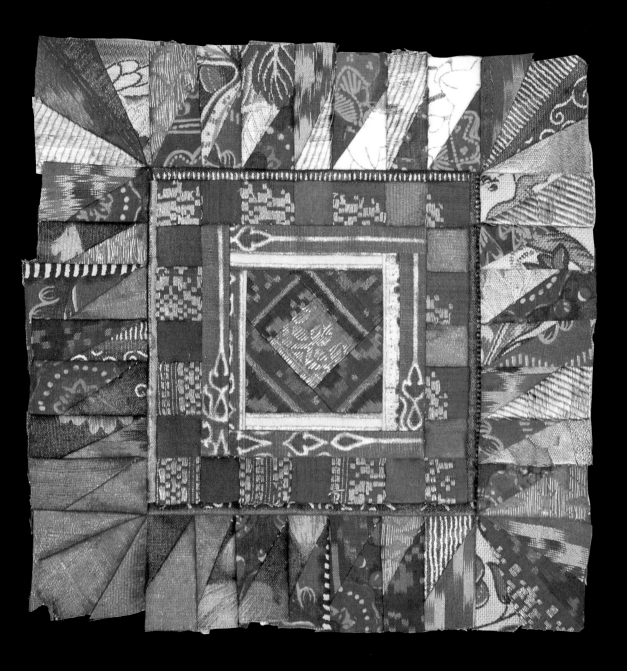

Several quilts from my Mandala series, each 5 ⅞ in. (15 cm) square, made from silk, cotton and pineapple fibers from India, Indonesia, Thailand, Japan and Laos.

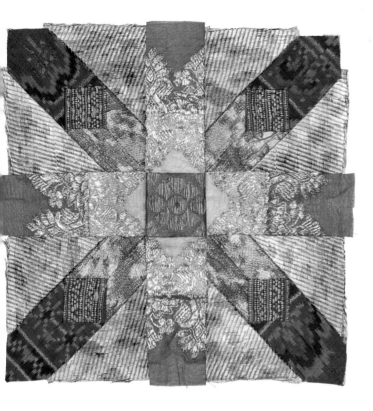

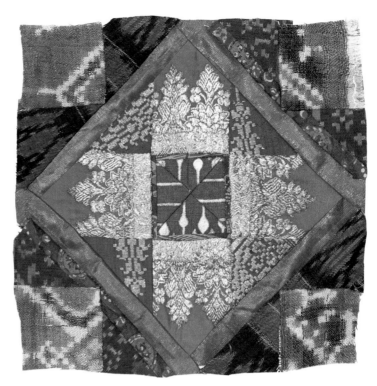

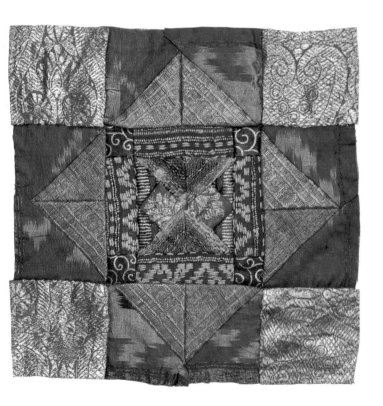

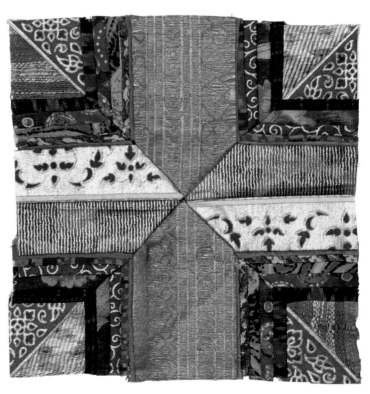

I have always been interested in the traditional designs produced in every part of Asia, and when traveling I have always collected pieces of antique and precious fabric. At some point, when I had amassed a myriad of bright scraps from all over the continent, I began to piece them together into what I think of as small quilt "mandalas."

Mandalas are found throughout Asia. Symbolic geometric or pictorial representations of the universe, they are sometimes used in Buddhist meditation.

Just as many countries and many different branches of Buddhism make up the colorful fabric of Asia, in my quilt mandalas I bring together an assortment of fabrics made by various ethnic groups: festive cloths of unparalleled technical artistry; silk *patola* cloths from India that express the essence of South Asian beauty; a Sumatran *songket*, or handwoven silk brocade shot with gold and silver thread; Indonesian batik; tropical cotton prints; and many more. Such folk fabrics reflect the climate of their origin and the technical artistry of their makers.

Antique cloth especially has many things to teach. There is an old tradition in Japan of handling rare or antique fabrics with respect, which has greatly enriched the culture. In the tea ceremony, for instance, old and elegant silk fabrics—a tea container covering, a square for wiping utensils, the bag to hold incense or a fan—are selected carefully to harmonize with the utensils that are used to prepare and serve the tea. Part of the respect for antique cloth involves studying it with a keen eye, to uncover the knowledge, promises and purposes stitched into its every fiber. Once a piece of antique cloth comes into our possession, before we can decide what use to make of it we must know how it was traditionally used.

To demonstrate the meaning of mandalas in my own way, I chose mainly red fabrics that express Asia's vitality. My mandalas all are $5\frac{7}{8}$ inches (15 centimeters) square. I find that that is the best size and shape for holding the mandala in your hand, admiring the textures of the fabric and the universal beauty of the design.

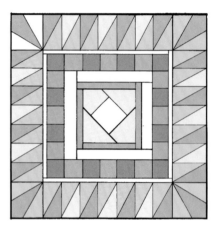

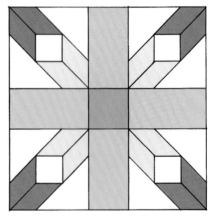

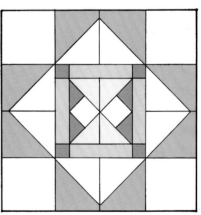

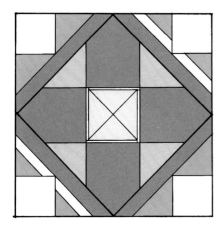

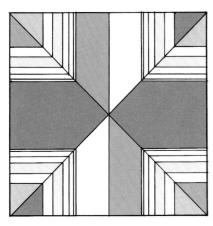

Usually you would construct a quilt by making a pattern and then cutting fabric to match, so that the fabric conforms to your rules. With antique fabrics, however, it is just the opposite. You must first deduce the plan of the fabric and then design your project accordingly. Pieces must be sewn together by hand to keep from pulling any strands out of place and destroying the integrity of the cloth.

Since many of the fabrics may be decorated with complicated patterns, the result may seem elaborate, but in fact the underlying layout is usually quite simple. Compare the photo of the mandala on page 39 (at top left) with the diagram on page 40 (center) and you'll see what I mean.

For this series you can also use combinations of interesting cotton prints, but I recommend including at least one woven fabric for texture and balance. European lace, antique velvet, and fabric from old Crazy Quilts could all make wonderful materials. When framing a finished block, be sure to leave plenty of space around the edges (if you like, you can hide the seam allowances at the edges, beneath the matting). These works are small but powerful. They make wonderful room decorations and gifts.

—As an interesting side note, there are two main kinds of mandalas. They are considered complementary and always appear together. They are known in Japanese as *taizokai* and *kongokai* mandalas, and have very different basic compositions. Oddly enough, the shape of each is very similar to a traditional quilting pattern: *taizokai* has a Log Cabin shape, and *kongokai* a Nine Patch.

Quilts in my Mandala series, each 5 $\frac{7}{8}$ in. (15 cm) square, made from silk, cotton and pineapple fibers from India, Japan, Indonesia, Thailand and Nepal.

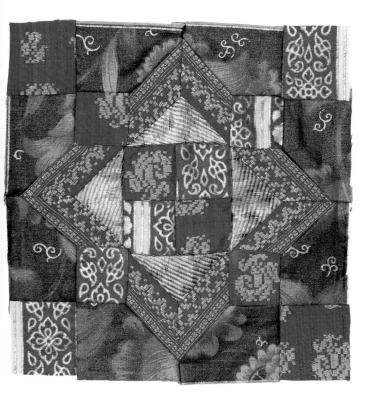

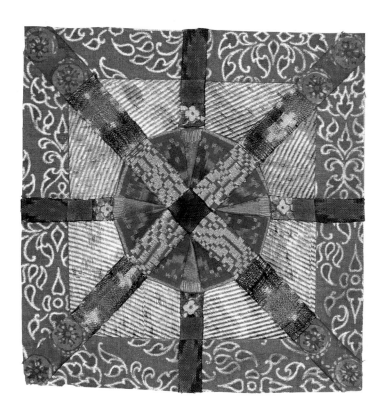

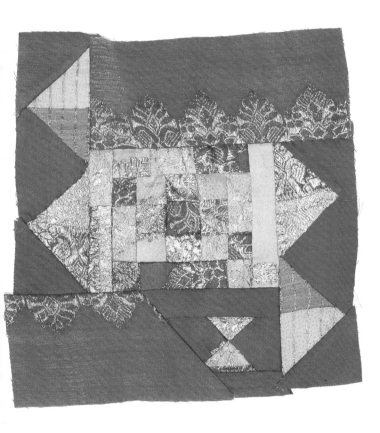

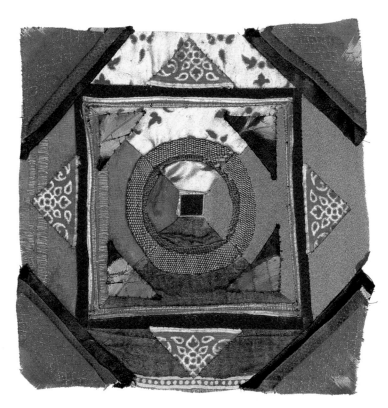

MORE DESIGNS CAN BE FOUND ON P. 116.

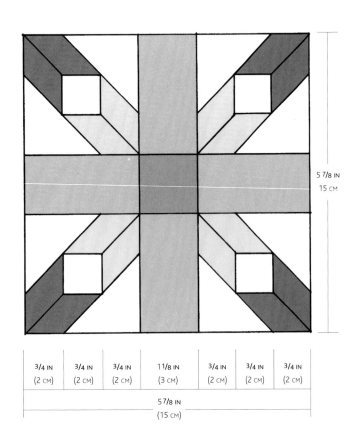

5 7/8 IN
15 CM

3/4 IN (2 CM)	3/4 IN (2 CM)	3/4 IN (2 CM)	1 1/8 IN (3 CM)	3/4 IN (2 CM)	3/4 IN (2 CM)	3/4 IN (2 CM)

5 7/8 IN
(15 CM)

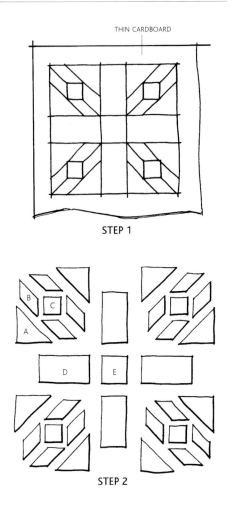

THIN CARDBOARD

STEP 1

STEP 2

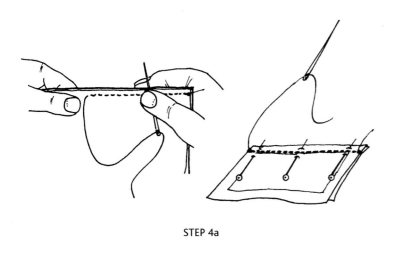

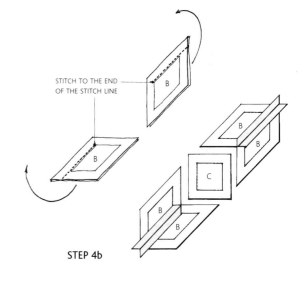

STITCH TO THE END
OF THE STITCH LINE

STEP 4b

☐ : OPEN SEAM ALLOWANCE

TECHNIQUE: Hand piecing
COMPLETED SIZE: 5 $\frac{7}{8}$ in. (15 cm) square

STEP 1: Trace the templates in actual size on thin cardboard and cut them out.

STEP 2: Label the templates A, B, C, D and E as shown.

STEP 3: Antique fabric comes in all sorts of conditions. If the threads look worn, place fine interfacing beneath the fabric (with fabric right side up), to avoid doing any damage. Leave a seam allowance of $\frac{1}{4}$ in. (8 mm). Cut out 8 patches of template A, 16 of B, 4 each of C and D and 1 of E, for a total of 33 (see p. 37, Step 3).

STEP 4a: Most pieces of antique cloth are homespun and fragile, and should be pieced by hand. If hand-sewing, pin the layers together and be sure to put in a back-stitch at the beginning and the end.

STEP 4b: As shown, place B and B together (right sides facing), and join. On the side closer to C, stitch to the end of the stitch line. Open the seam allowance. Join C to 2 B-B blocks.

STEP 4c: Fold over the seam allowance as shown. Piece an A on either side. Piece 3 more blocks the same way.

STEP 4d: Join D to 2 Step 4c blocks, folding the seam allowance towards D. Join D, E and D, folding the seam allowance towards E. Finally, join the 3 strips, folding the seam allowance towards D.

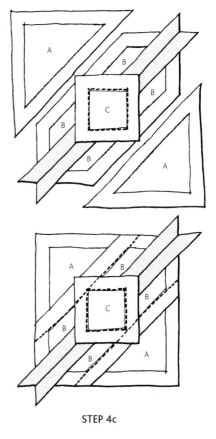

STEP 4c

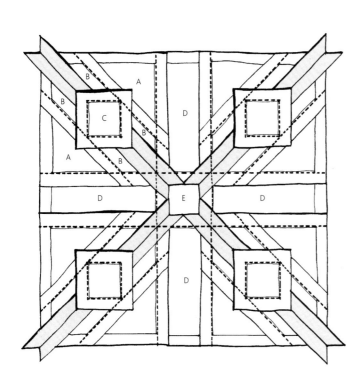

STEP 4d

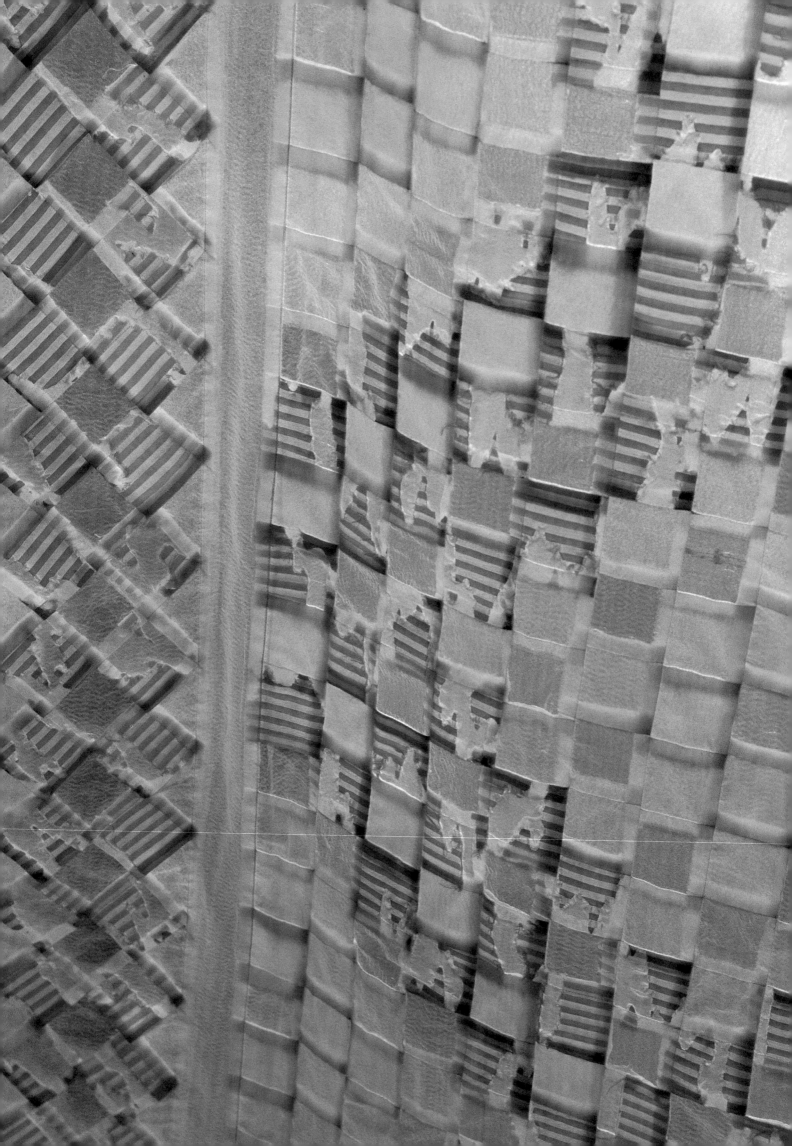

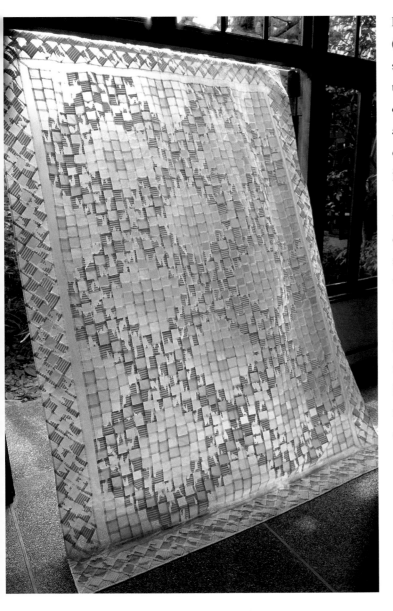

Here I focused on the interesting fabric called *"Hibiware"* (Fissures), combining it with a diaphanous white fabric of sheer nylon created by Jun'ichi Arai. I realized that if I used this sheer fabric in a layered structure I could alter the level of its transparency by varying the number of layers, creating a motif of light and shadows. I chose a simple quilt design, cut out all the pieces in identical small squares and then joined them back together.

I overlapped the seam allowances in many places so that when held up to the light, the details of overlapping cloth create a light, pleasing rhythm. By joining the pieces of "fissured" fabric in a geometric pattern, I achieved a natural wavy look.

The key points of this design are the shading of the sheer fabric through layering, and the rhythmical effect of overlapping seam allowances. The choice of a classic pattern—in this case, Irish Chain—makes the contemporary materials look even more modern. Making this quilt, I was struck by the beauty of the traditional quilting patterns that have been sewn by so many different people across the years.

Transparent Quilt: "Watermark." Nylon, polyester, rayon. 72 ½ x 99 ⅝ in. (183 x 253 cm).

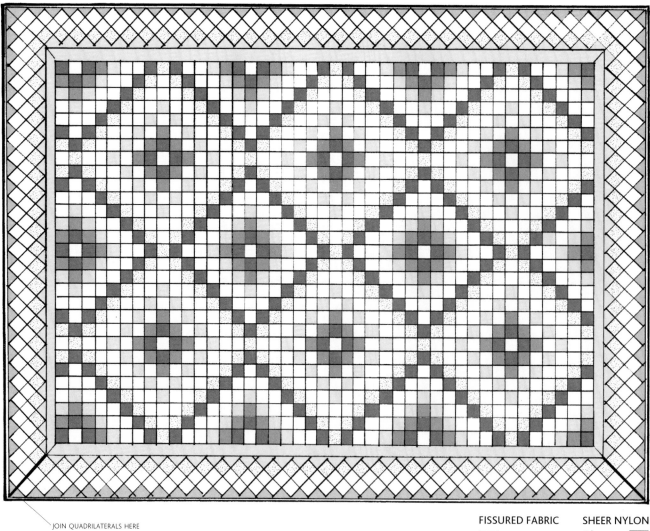

JOIN QUADRILATERALS HERE

FISSURED FABRIC	SHEER NYLON
☐ USE RIGHT SIDE	5 layers �
	4 layers ▮
▩ USE WRONG SIDE	3 layers ▯
	2 layers ▯
	1 layer

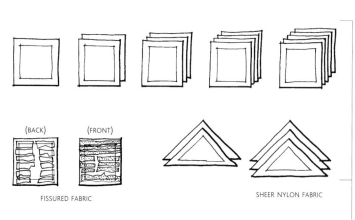

(BACK) (FRONT)

FISSURED FABRIC

SHEER NYLON FABRIC

STEP 2

STEP 3

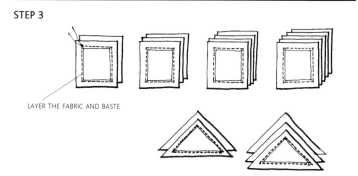

LAYER THE FABRIC AND BASTE

MATERIALS: Nylon, polyester, rayon

SHEER NYLON: 1 yd. 7¼ in. x 21 yds. 31⅜ in. (110 cm x 20 m)

FISSURED FABRIC (nylon/polyester/rayon blend): 1 yd. 7¼ in. x 3 yds. 29¾ in. (110 x 350 cm)

TECHNIQUE: Machine piecing

COMPLETED SIZE: 72½ x 99⅝ in. (183 x 253 cm)

STEP 1: Make cardboard templates of a 2-in. (5-cm) square and a 2-in. (5-cm) isosceles triangle.

STEP 2: Cut the nylon fabric and the fissured fabric into 2¾-in. (7-cm) squares (this allows for ⅜-in. [1-cm] seam allowances on all sides). Cut the nylon fabric into 2¾-in. (7-cm) isosceles triangles. Arrange the nylon squares into piles of from 1 to 5 and the nylon triangles into piles of 2 and 3. The fissured cloth is not layered; use just 1 square at a time, but alternate between using the right and wrong sides. Referring to the overall pattern, cut out the necessary number of pieces.

STEP 3: Overlap the squares and triangles in layers of 2, 3, 4 and 5 pieces as shown, and baste just outside the stitch line.

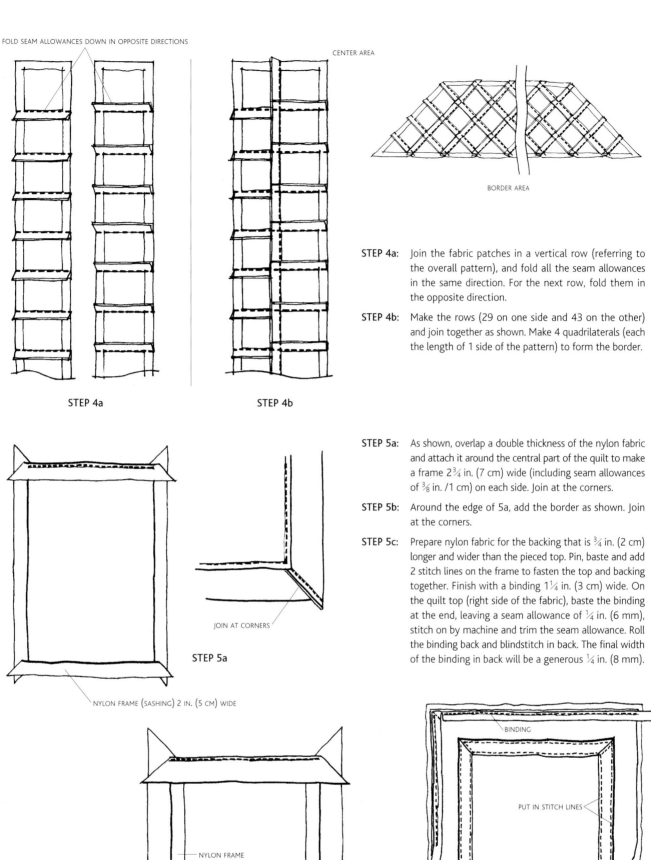

FOLD SEAM ALLOWANCES DOWN IN OPPOSITE DIRECTIONS

CENTER AREA

BORDER AREA

STEP 4a

STEP 4b

STEP 4a: Join the fabric patches in a vertical row (referring to the overall pattern), and fold all the seam allowances in the same direction. For the next row, fold them in the opposite direction.

STEP 4b: Make the rows (29 on one side and 43 on the other) and join together as shown. Make 4 quadrilaterals (each the length of 1 side of the pattern) to form the border.

JOIN AT CORNERS

STEP 5a

NYLON FRAME (SASHING) 2 IN. (5 CM) WIDE

STEP 5a: As shown, overlap a double thickness of the nylon fabric and attach it around the central part of the quilt to make a frame 2¾ in. (7 cm) wide (including seam allowances of ⅜ in. /1 cm) on each side. Join at the corners.

STEP 5b: Around the edge of 5a, add the border as shown. Join at the corners.

STEP 5c: Prepare nylon fabric for the backing that is ¾ in. (2 cm) longer and wider than the pieced top. Pin, baste and add 2 stitch lines on the frame to fasten the top and backing together. Finish with a binding 1¼ in. (3 cm) wide. On the quilt top (right side of the fabric), baste the binding at the end, leaving a seam allowance of ¼ in. (6 mm), stitch on by machine and trim the seam allowance. Roll the binding back and blindstitch in back. The final width of the binding in back will be a generous ¼ in. (8 mm).

NYLON FRAME

ATTACH THE BORDER

STEP 5b

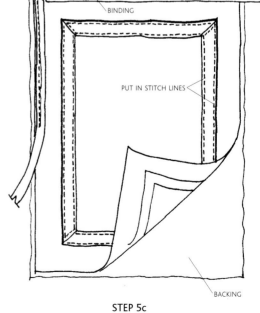

BINDING

PUT IN STITCH LINES

BACKING

STEP 5c

Shimmering Cushions. Nylon, polyester, aluminum-coated nylon, aluminum-coated polyester.

Participating in a workshop on using melt-off on gold and silver fabric gave me the chance to create several striking, unique materials. "Melt-off" is the process of dissolving parts of the metallic coating on slit-film yarn by treating it chemically, and then dyeing the fabric. One day I came up with a surprising result: a fabric with scarcely any remaining gold or silver that still retained a faint gleam. By overlapping one, two, three or more sheets of that fabric, I was able to achieve subtle gradations of color.

But I didn't want to express everything through the fabric alone; I wanted the quilting too to have an integral role in the project. So although the materials are modern and innovative, the quilting gives the cushion a handcrafted quality and an improvisational beauty.

For the quilt motif you may choose a shell, a plant, an herb garden, or whatever you like. Try freehand quilting with some abandon. The result is likely to be more attractive if you allow your imagination free rein.

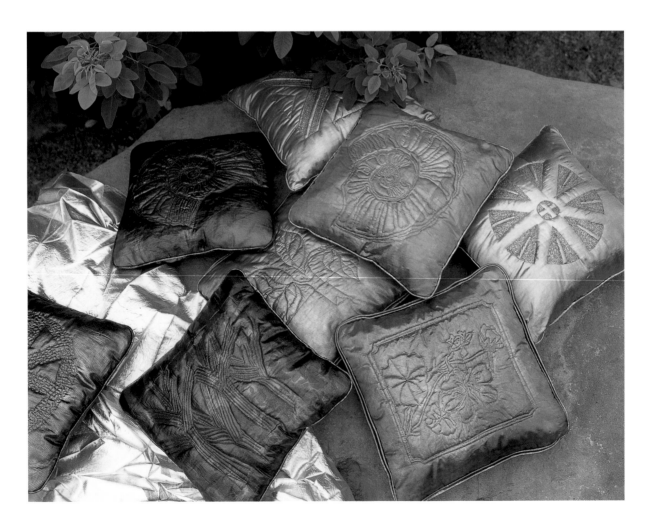

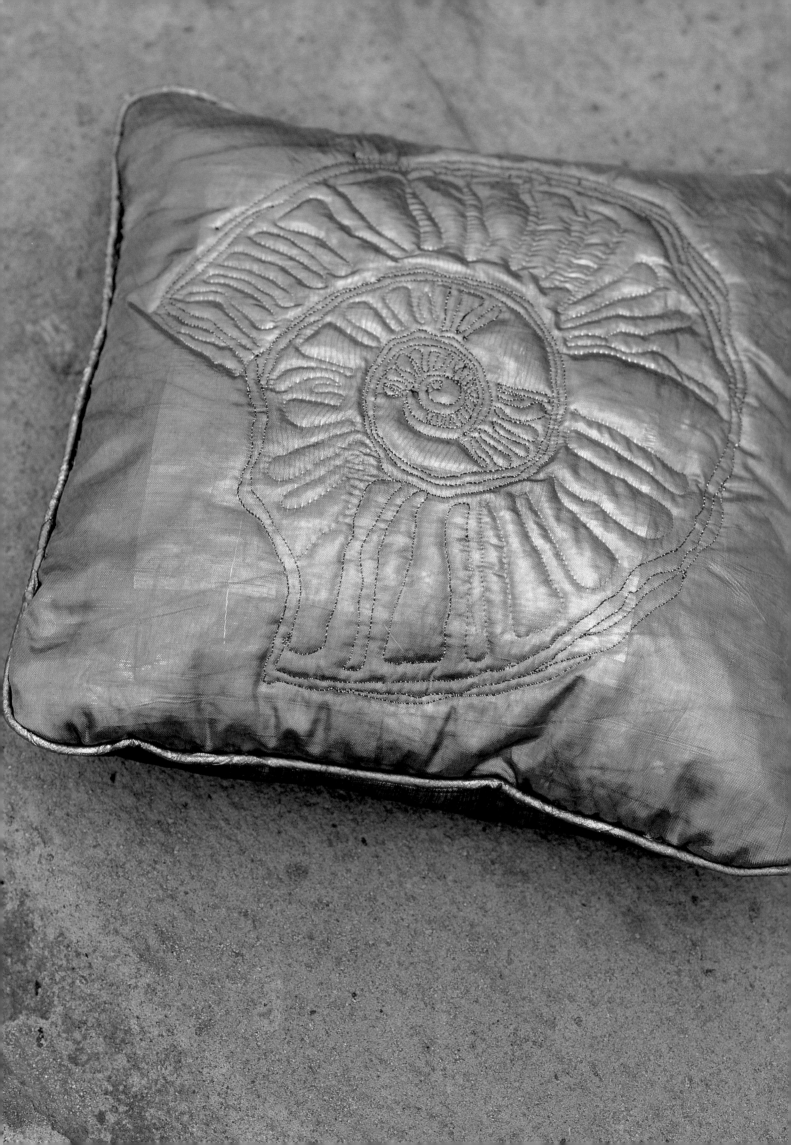

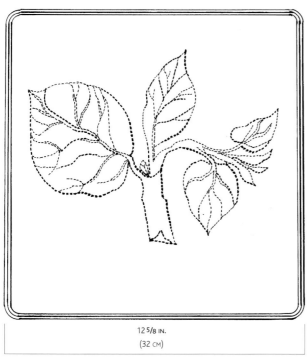

12 5/8 IN.
(32 CM)

(INCLUDING DOUBLE CORD PIPING OF
TOTAL 3/8 IN. / 1 CM ON ALL SIDES)

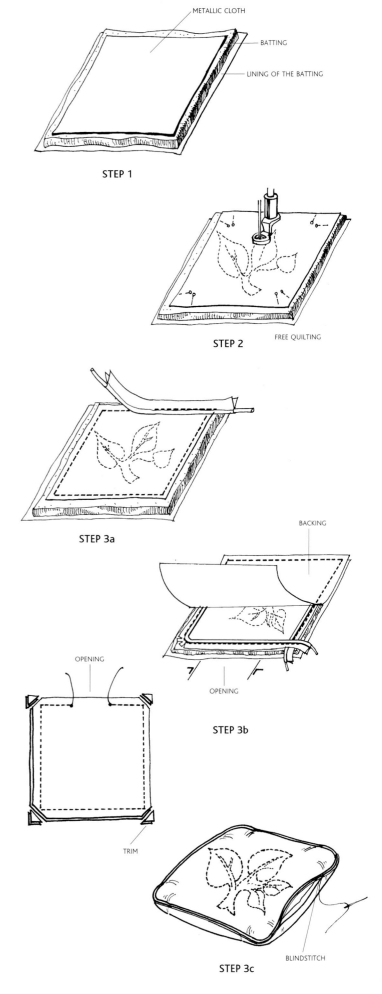

STEP 1

STEP 2

FREE QUILTING

STEP 3a

BACKING

STEP 3b

OPENING

OPENING

TRIM

BLINDSTITCH

STEP 3c

MATERIALS: Nylon, polyester, rayon, aluminum-coated nylon, aluminum-coated polyester, cotton

TOP CLOTH: Metallic cloth 13 ¾ in. (35 cm) square

BATTING: Polyester 14 ¼ in. (36 cm) square

LINING OF THE BATTING: Thin cotton 14 ½ in. (37 cm) square

BACKING: Metallic cloth 13 ¾ in. (35 cm) square

EDGING:

 SINGLE CORD PIPING: Bias tape 1 ⅜ in. x 1yd. 12 ¾ in. (3.5 x 130 cm)

STUFFING: Polyester or cotton

COMPLETED SIZE:

 WITH SINGLE CORD PIPING: 12 ¼ in. (31 cm) square

 WITH DOUBLE CORD PIPING: 12 ⅝ in. (32 cm) square

TECHNIQUE: Free-motion machine quilting

STEP 1: Prepare 2 squares of metallic cloth for the quilt top and backing. Prepare cloths for the batting and lining of the batting that are slightly larger than the top cloth.

STEP 2: Transfer the design to the right side of the fabric with chalk paper or sketch it on a piece of paper and do free-motion machine quilting directly onto the cloth.

STEP 3a: Baste where you want the finished outer edges to be and machine stitch the cord piping on as shown, along the inner edge. Make several small cuts at each corner. The cord piping can be doubled if you like (see p. 61 for instructions on cord piping).

STEP 3b: Place the backing (right side down) over the cord piping and machine stitch. Leave an opening on one side as shown. Trim and smooth the seam allowance.

STEP 3c: Pull the cushion inside out through the opening. Smooth out the shape and insert the stuffing. Blindstitch the opening by hand.

NOTE: Only the top is quilted. For the backing, I use a single plain piece of cloth.

METALLIC CLOTH

BATTING

LINING OF THE BATTING

THESE CUSHIONS ARE 12 1/4 IN. (31 CM) SQUARE, INCLUDING SINGLE CORD PIPING OF BETWEEN 1/8 IN. AND 1/4 IN. (5 MM) ON ALL SIDES.

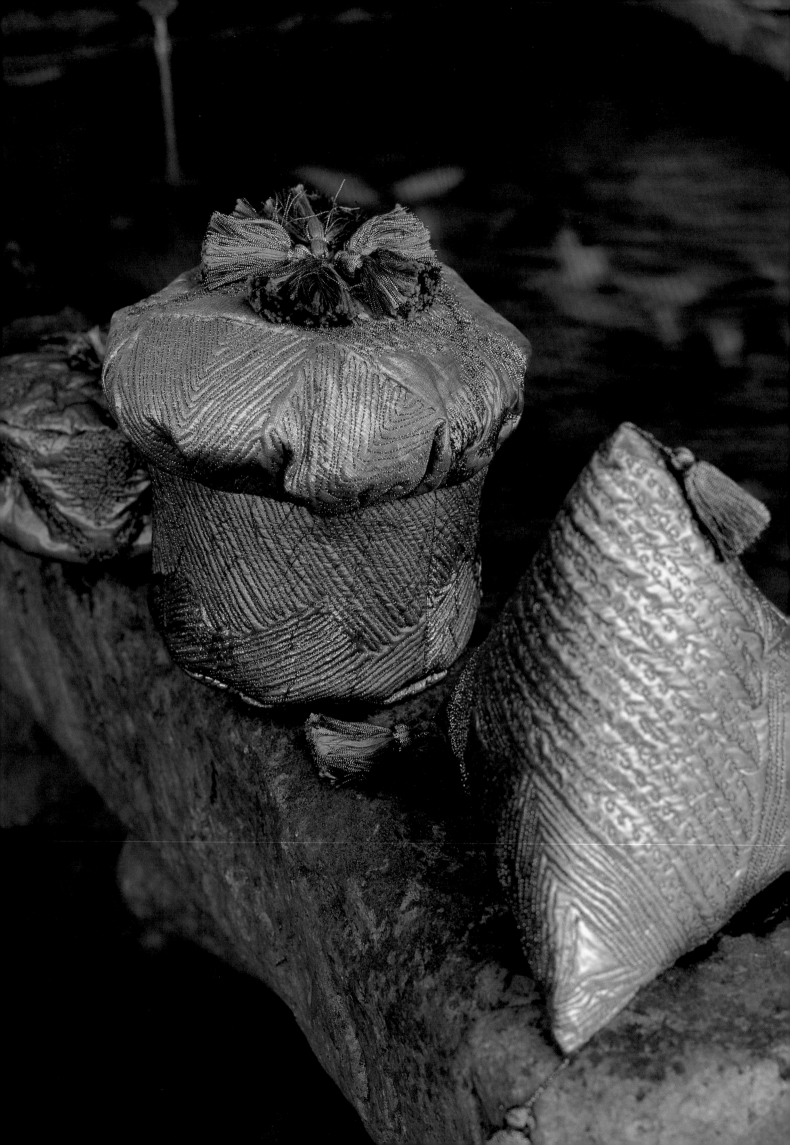

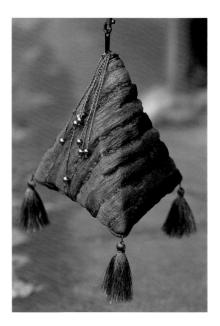

Sometimes finding new work materials can bring to mind all kinds of ideas for new projects. I have many embroidered sarongs (ceremonial *sarung tapis* woven in striped cotton and embroidered in gold) from Lampung, Sumatra that display endless contrasts of light and shadow; no two are alike. These sarongs were an inspiration to me, and the quilting that I did in these objects made from silver cloth is modeled on their stitchwork. In this series of accessories the raised quilted surfaces combine with the material itself to produce an interesting interplay of light and shadow.

Here I used silver fabrics created by Jun'ichi Arai, but I first tried to give them more of a handmade feeling by melting off some of the metal threads and then layering the cloths in various ways. I used free-motion quilting for an irregular stitch line that would avoid a uniform metallic look. Cloth of spun silver can be shaped more easily than other fabrics, and even the puckering on the quilted surface retains its shape well over time.

These items could also be adapted and made into personal accessories such as bags. Try adding cords or belts, moving the opening, or coming up with other variations of your own. Such original touches will make your creations even more unique.

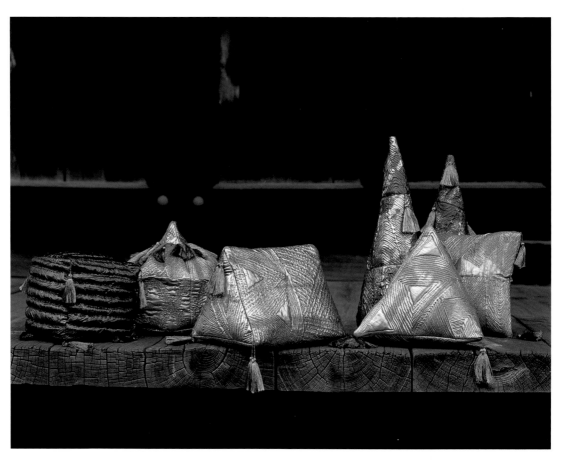

Lampung embroidery series.
LEFT AND RIGHT: Decorative objects.
ABOVE RIGHT: Bag.

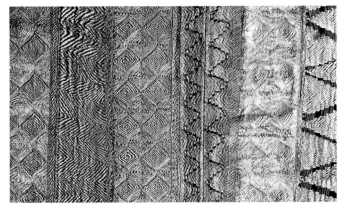

Sarung tapis. Embroidery done with gold threads on vertically striped cotton. Lampung, Sumatra. Author's collection.

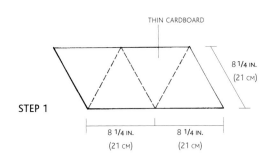

STEP 1

THIN CARDBOARD

8 1/4 IN. (21 CM)

8 1/4 IN. (21 CM) 8 1/4 IN. (21 CM)

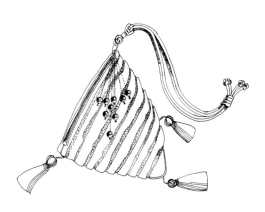

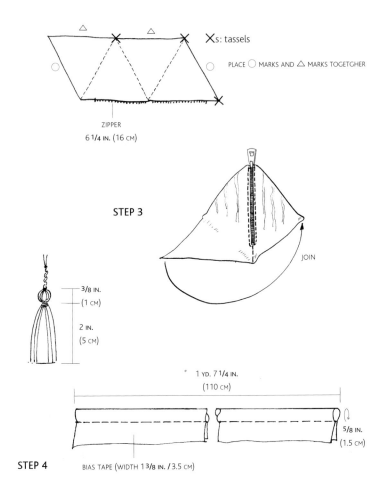

QUILT TOP

BATTING

LINING OF THE BATTING

STEP 2

1 1/8 IN. (3 CM)

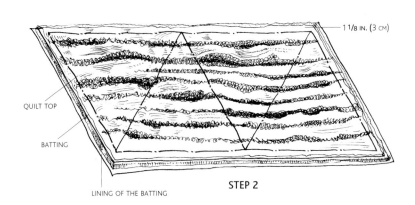

Xs: tassels

PLACE ○ MARKS AND △ MARKS TOGETGHER

ZIPPER

6 1/4 IN. (16 CM)

STEP 3

JOIN

3/8 IN. (1 CM)

2 IN. (5 CM)

1 YD. 7 1/4 IN. (110 CM)

5/8 IN. (1.5 CM)

STEP 4 BIAS TAPE (WIDTH 1 3/8 IN. / 3.5 CM)

BAG

MATERIALS: Polyester, nylon, stainless steel thread, titanium beads
TOP CLOTH: Polyester/nylon blend
BATTING: Polyester
LINING OF THE BATTING: Thin cotton
LINING: Polyester
STRAP: 2 cords of 1 yd. 7 1/4 in. (110 cm)
ORNAMENTS: Stainless steel thread, titanium beads
TECHNIQUE: Free-motion machine quilting
(**NOTE:** All cloths required are 23 1/2 x 12 in. /60 x 30 cm)

STEP 1: Following the diagram, make a template from thin cardboard.

STEP 2: Prepare the top cloth, allowing a good 1 1/8 in. (3 cm) for the seam allowance. The batting and lining of the batting should be larger than the top; baste together in 3 layers as shown and do free-motion machine quilting.

STEP 3: Attach zipper as shown. Stitch the bottom, matching the O's and the triangles. Make the lining (using the template from Step 1), leaving an opening. Turn the lining and top cloth inside out and insert top cloth into lining through the opening. Blindstitch the edges of the zipper to the opening and pull bag inside out.

STEP 4: If making your own cords for the strap, prepare 2 bias tapes. If the cloth is thin, attach fine interfacing. As in the diagram, fold in half and stitch along the line 1/4 in. (7.5 mm) from the top. When the cords are turned inside out, the seam allowance will serve as padding. Fold each one in half. String beads onto metallic threads and attach to the zipper handle.

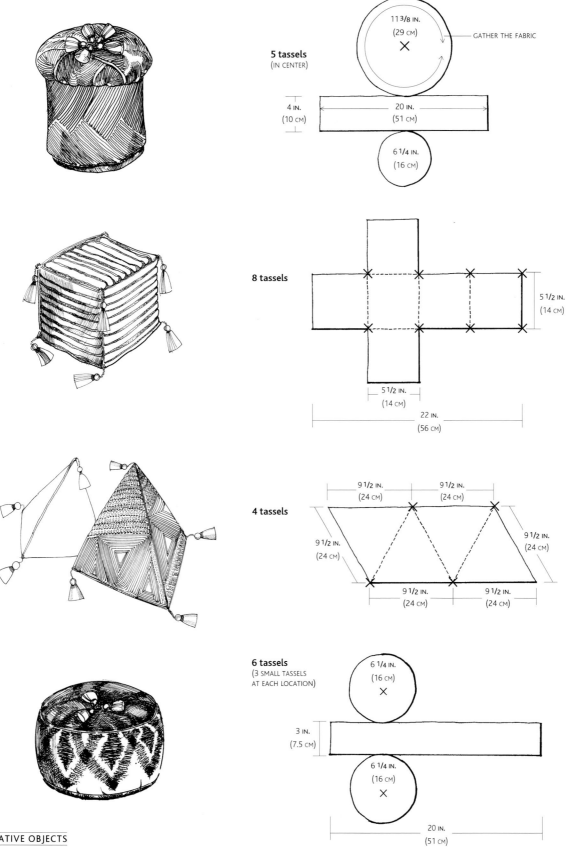

5 tassels
(IN CENTER)

11 3/8 IN.
(29 CM)

GATHER THE FABRIC

4 IN.
(10 CM)

20 IN.
(51 CM)

6 1/4 IN.
(16 CM)

8 tassels

5 1/2 IN.
(14 CM)

5 1/2 IN.
(14 CM)

22 IN.
(56 CM)

4 tassels

9 1/2 IN.
(24 CM)

9 1/2 IN.
(24 CM)

9 1/2 IN.
(24 CM)

9 1/2 IN.
(24 CM)

9 1/2 IN.
(24 CM)

9 1/2 IN.
(24 CM)

6 tassels
(3 SMALL TASSELS
AT EACH LOCATION)

6 1/4 IN.
(16 CM)

3 IN.
(7.5 CM)

6 1/4 IN.
(16 CM)

20 IN.
(51 CM)

DECORATIVE OBJECTS

MATERIALS: Nylon, polyester, rayon, aluminum-coated nylon, aluminum-coated polyester
BATTING: Polyester
LINING OF THE BATTING: Thin cotton
STUFFING: Polyester or cotton
TECHNIQUE: Free-motion machine quilting

STEP 1: Do free-motion machine quilting as in p. 52, Step 2.

STEP 2: Complete each item in the shape desired and stuff. Attach tassels at the Xs (for instructions on making tassels, see p. 85).

MORE PATTERNS CAN BE FOUND ON P. 117.

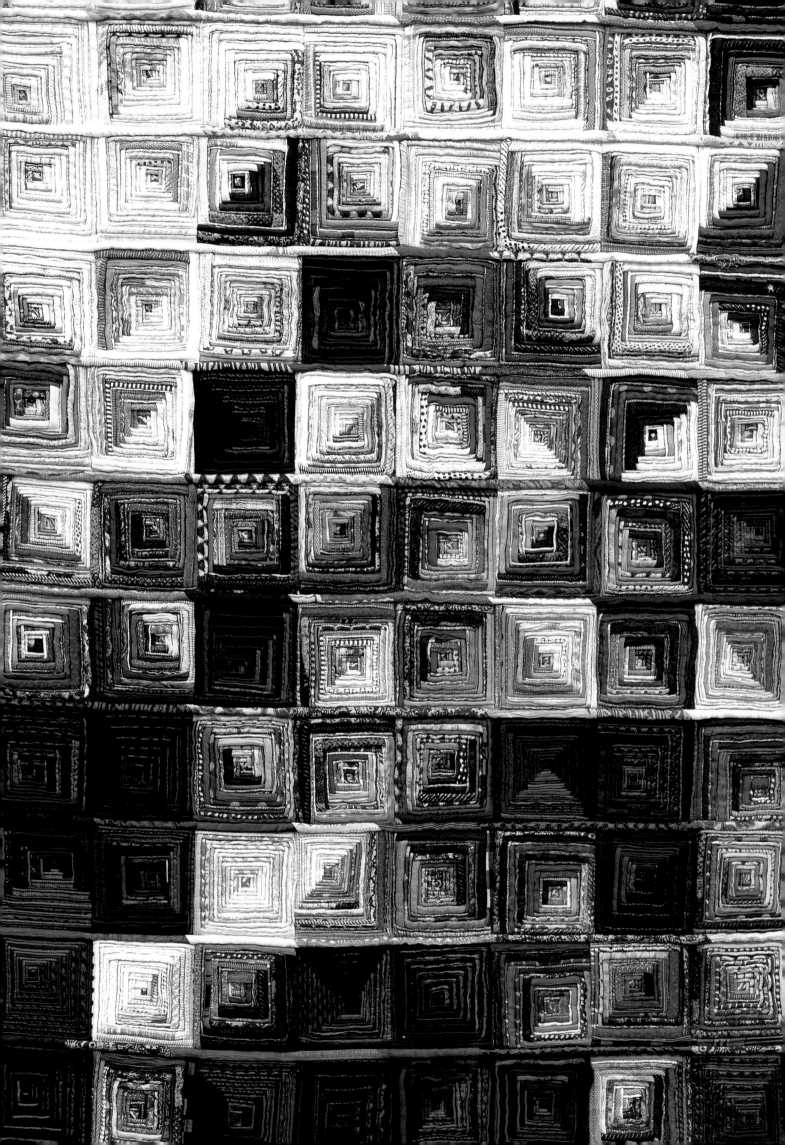

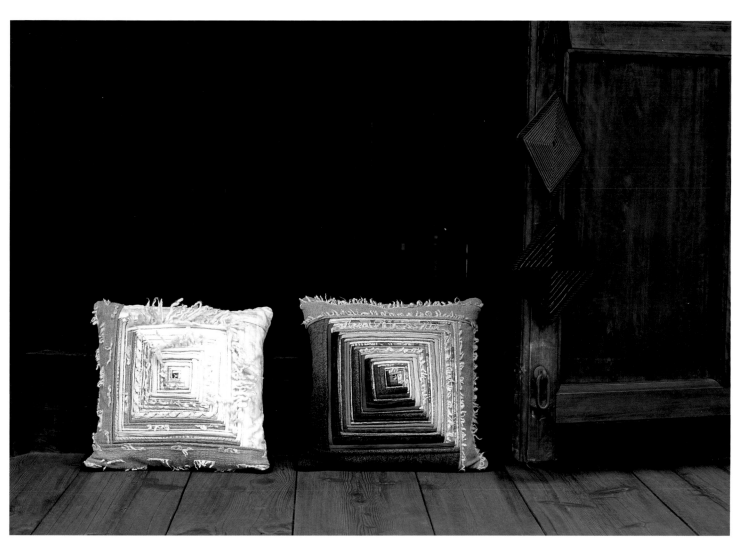

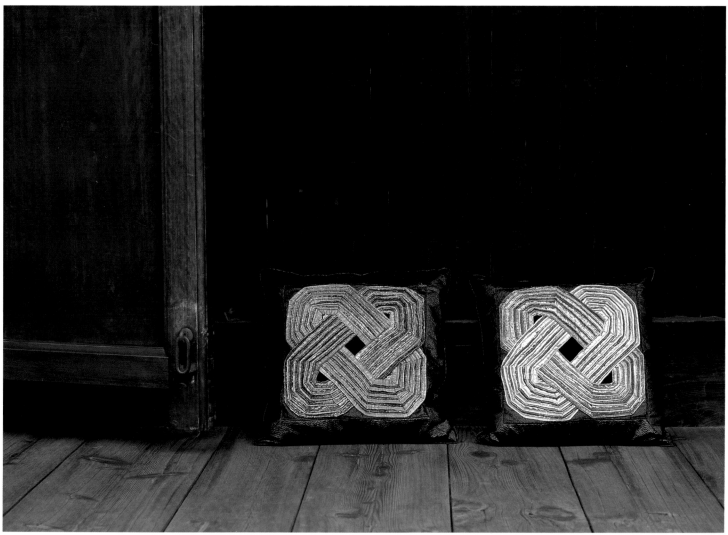

PAGE 58: Spiral Block Quilt: "Versification II." PAGE 59 ABOVE: Spiral Block Cushions and Small Spiral Block Bags (INSTRUCTIONS FOR MAKING BAGS ARE ON P. 119). BELOW: African Spiral Cushions (INSTRUCTIONS FOR MAKING CAN BE FOUND ON P. 118).

The spiral blocks in the quilt shown on page 57 (and on pages 20–21) are smaller variations of those seen here in the Spiral Block Cushions.

When I first encountered the fabrics of Jun'ichi Arai, I wanted to use them in a quilt that would serve as a catalog of the technological innovations he had made until then—throughout the seventies and eighties—and at the same time would be my own original work. His fabrics were used for the most part in ground-breaking fashions, and each piece was made with such consummate, powerful artistry that they seemed too strong to be shown together in one quilt. At the same time, I didn't want to do anything to dissipate that strong individuality. I decided that the best way to balance these concerns was to combine as many different kinds of fabric as possible in a single quilt, and the method I hit upon for doing that was the spiral block technique.

This process makes it possible to assemble as many as two hundred kinds of fabric in a single quilt. I lay down pieces of cloth between 2 and 2 ¼ inches (5–6 centimeters) square and enclose them in such a way that only a strip 1 centimeter wide is exposed on the surface. Developing the idea took four years, but I am happy with the result.

SPIRAL BLOCK CUSHIONS

Gather a number of interesting fabrics with contrasting textures to make a striking cushion. The spiral block technique joins cloths of richly varied texture in a spiral chain. Materials should be sorted according to texture and type: soft or stiff, rough or smooth, glossy or dull, colorful or plain. You may want to include fabrics like metallic cloth, fringed or woven-edged cloth and felted wool. When making ribbon, select cloths for their texture and insert cord piping to add dimension. Depending on your materials (their relative bulk and elasticity), the cord may be single or double, thinner or thicker. Use shiny metallic cloth for accent in the center, creating a rhythmical interaction of wider and thinner cord piping. Frame with wide pieces of fabric; this gives the spiral block a three-dimensional effect, and the finished cushion takes on a smooth, curved shape. If you go through your closet you are likely to find clothes that no longer fit or that you no longer wear, often with exciting textures and wonderful possibilities as quilting material. Light or heavyweight wool in sweaters and slacks can be used along with synthetic textiles, mixing in metallic cloth for added texture. The spiral block technique makes it possible to recycle all sorts of fabrics, bringing them back to life in another form. I like to use winter clothes to make winter cushions and summer clothes to make summer ones.

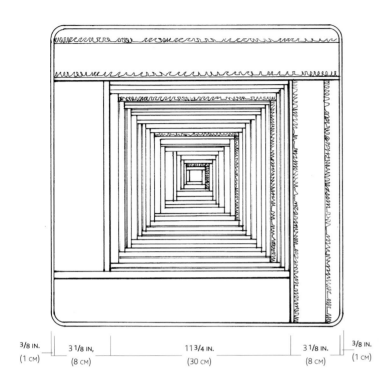

| 3/8 IN. | 3 1/8 IN, | 11 3/4 IN. | 3 1/8 IN. | 3/8 IN. |
| (1 CM) | (8 CM) | (30 CM) | (8 CM) | (1 CM) |

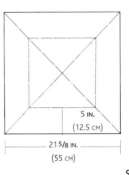
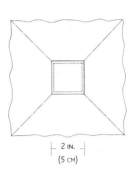

5 IN.
(12.5 CM)

21 5/8 IN.
(55 CM)

2 IN.
(5 CM)

STEP 1

MATERIALS: Silk, wool, cotton, nylon, polyester, rayon, cupra (cupramonium rayon), titanic oxide–coated nylon, synthetic rubber

BASE CLOTH: Thin cotton 21 ⅝ in. (55 cm) square

BACKING: Black velvet 20 in. (50 cm) square

EDGING: Black velvet bias tape cord piping 2 in. x 2 yds. 14 ⅝ in. (5 x 220 cm)

CORD: Knitting yarns of various thicknesses

STUFFING: Polyester

TECHNIQUE: Piecing of cord piping

COMPLETED SIZE: 18 ⅞ in. (48 cm) square

STEP 1: Prepare the base cloth and baste marking lines along the diagonals and in a square in the center. Place a 2-in. (5-cm)–square patch of metallic cloth in the center and baste ⅜ in. (1 cm) from the outer edge.

STEP 2: Prepare cloths with various textures. Use cords of different widths for variety in cord piping. (You can either use small fabric scraps to make individual lengths of cord, or longer pieces that you then cut.) Do not align the edges.

STEP 3: As in the diagram, sew cord piping (1) to the central metallic block and cut, leaving a seam allowance. Sew on (2) and (3) in turn, continuing the same way until you have made a 11 ¾-in. (30-cm)–square block. Leave a wide margin of cloth around the outer edge. To sew the cushion, refer to p. 52, Steps 3a–3c.

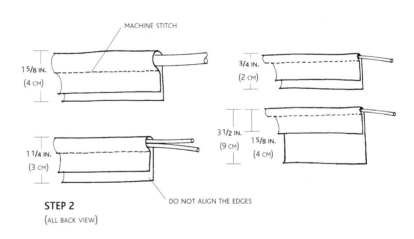

MACHINE STITCH

1 5/8 IN.
(4 CM)

1 1/4 IN.
(3 CM)

3/4 IN.
(2 CM)

3 1/2 IN.
(9 CM)

1 5/8 IN.
(4 CM)

STEP 2
(ALL BACK VIEW)

DO NOT ALIGN THE EDGES

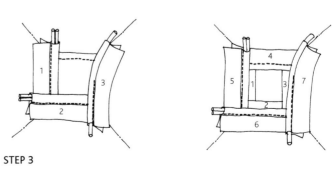

STEP 3

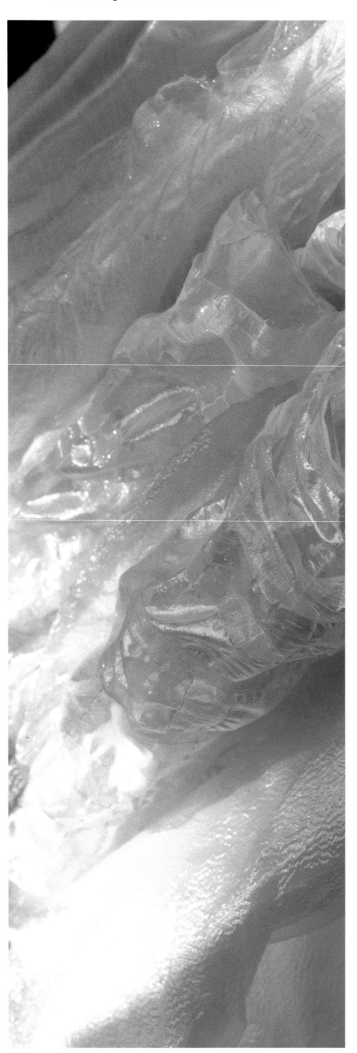

Optical Quilt: "Star Connection." Nylon dyed with natural dyes. 68 ½ x 83 ⅞ in. (174 x 213 cm). LEFT: The material used to make this quilt.

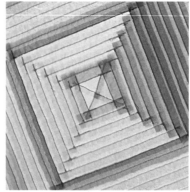

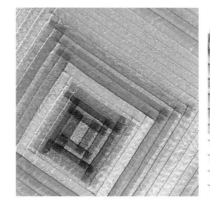

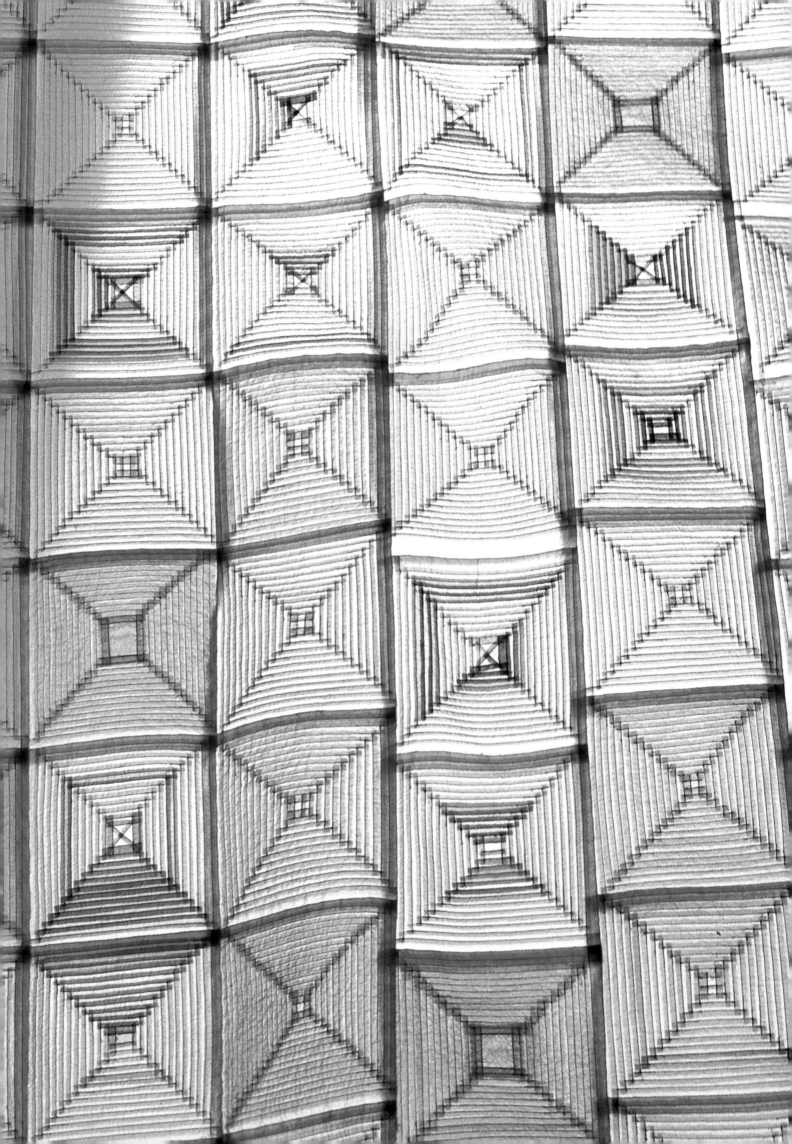

I tried dyeing nylon—a synthetic fabric created for industrial use—with various natural dyes. It took the dye beautifully every time, acquiring new vitality and a whole new look. This combination got me thinking. Today we have developed our capacity for industrial production tremendously in our efforts to produce standardized high-quality goods. In the process, I wondered, what have we discovered, and what have we lost? In my Optical Quilt series I wanted to explore those questions. The introduction of natural dye into the world of synthetic fabrics yields cloth with an atmosphere of surprising warmth. At the same time, the feeling of the cloth against our skin is a familiar sensation of the twentieth century.

The base cloth of this quilt is bamboo-dyed white; for the accent colors, I used vividly colored dyes from tropical plants. Through the traditional Log Cabin pattern of North America I sought to create a tension or contrast with the contemporary materials.

—By the way, the quilt shown on the jacket and on pages 10–11, Optical Quilt: "Shimmering Waves," has a top cloth of this same nylon dyed with natural dyes, but it has a total of 8 layers of different synthetics and bamboo-dyed silk. To make the most of the transparent nature of the materials, I set all kinds of small pieces of naturally dyed accent color fabrics cut into interesting shapes on the various layers and basted, then did free-motion quilting through all the layers.

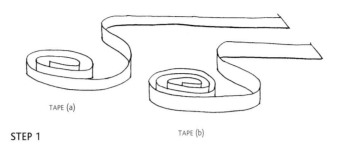

TAPE (a)

STEP 1

TAPE (b)

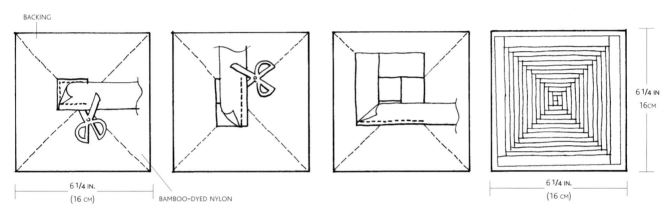

BACKING

6 1/4 IN.
(16 cm)

BAMBOO-DYED NYLON

6 1/4 IN
16CM

6 1/4 IN.
(16 cm)

STEP 2

MATERIAL: Nylon dyed with bamboo and *soga*
TECHNIQUE: Machine piecing
NYLON: Bamboo-dyed nylon 1 yd. 7 ¼ in. x 21 yds. 31 ⅜ in. (110 cm x 20 m)
ACCENT CLOTH: Nylon dyed with bamboo and *soga* 1 yd. 7 ¼ in. x 3 yds. 10 ⅞ in. (110 x 300 cm)
SIZE: 68 ½ x 83 ⅞ in. (174 x 213 cm)

STEP 1: Cut the bamboo-dyed nylon into 2 tapes. Tape (a) should be ½ in. (1.3 cm) wide and tape (b) ¾ in. (2 cm) wide. Tape (b) will be used on the outer layer of the Log Cabin blocks. Do the same with the accent color.

STEP 2: Construct the Log Cabin blocks. Cut the bamboo-dyed nylon into 6 ¼-in. (16-cm) squares and baste marking lines along the diagonals. Cut tape (a) into a ½-in. (1.3-cm) square (including the ¼-in. / 4-mm seam allowance). Following the diagram, baste the square to the bamboo-dyed nylon. With all the remaining squares lay the length of tape over the first square, sew one side down, cut the tape away to leave a square shape and fold down, then lay the tape over that and repeat. Use tape (b) for the wide outer layer.

STEP 3: With the accent cloth, construct the accent blocks using patterns A and B. **ACCENT BLOCKS PATTERNS A AND B CAN BE FOUND ON P. 120.**

STEP 4: To join the blocks, see p. 49, Steps 4a–4b but here seam allowances should all be pressed in the same direction. Join the blocks with no binding. Referring to the illustration of the whole pattern, vary the size of the blocks, making it 5 ⅛ or 5 ½ in. (13 or 14 cm), to slightly stagger the rows. The unevenness will add motion and visual interest.

NOTE: When I display this quilt I hang it in the middle of the room like a partition so it can be seen from both sides.

Scenes from around my studio in Bali.

PART 2

QUILTS MADE FROM FABRIC
OR FIBERS I DYED MYSELF

Grass House Studio

I first visited the tropical island of Bali in 1983. Every breeze carried the sound of rustling coconut leaves, and offerings of flowers and incense lent vibrant color and a sense of peace. I began to experience a different flow of time, to discover a world I had never seen or heard of before. With every trip I made to Bali my dream of one day opening a studio there grew stronger.

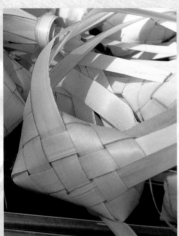

Ketupat braided coconut leaves.

Work on the studio began in 1989, in a corner of a palm grove in the quiet village of Kesiman, which lies among the hills inland from Sanur. The first tasks were to dig wells and plant trees on what had been fields of tapioca. After that, I had four goals: to protect the environment, to convey the essence of south Asia as I'd come to know it in my travels, to find a design that would allow for optimal wind passage between the buildings, and to create a living space that blended in with the nature around it. The building materials were taken as-is from nature: stones transported from the high mountain in the middle of the island, grass growing wild in the hills, palm trees, bamboo, roof tiles of unglazed earthenware, huge rocks from the bottom of the sea, coral from the atoll.

As construction moved along, I made many discoveries about the rhythms and materials of nature, acquiring traditional techniques and wisdom from the past while working alongside modern villagers and artisans. For the roof we wove a giant tapestry of grass and bamboo, and with bits of coral we made a stony quiltlike pattern on the outer wall. We laid down small stones in a spiral pattern on the floor of the entryway. When construction was completed at last, I named it "Grass House Studio."

My silk version of a *ketupat* (instructions are given at right and below).

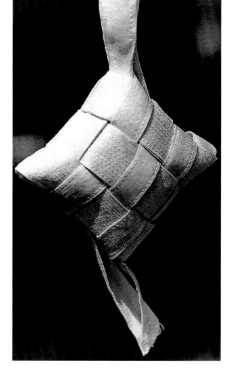

In Bali, people's lives revolve around events in the calendar, and New Year's, or Galungan, is the most important festival of the year. At every front gate, stalks of cut bamboo about twenty-five feet (eight meters) tall are said to guide the ancestors and gods who at that time of year descend the sacred mountain and enter people's homes. These stalks of bamboo, called *penjors*, are hung with young palm fronds, little shells that clatter when the wind blows and *rontal*-leaf decorations that women have cut, folded, woven and tied. Human expertise is added to nature's gifts to make them into offerings for the gods. The preparation of sacred offerings goes on without fuss or fanfare, as quietly as the preparation of daily meals.

At Grass House Studio, my day begins with collecting jasmine flowers that have fallen on the ground. Afterward I burn some fragrant *liligundi* to fumigate the thatched roof and chase away any small insects that may have settled there. The perfumed smoke drifting idly from the eaves out into the garden is refreshing to the spirit. Over the ground is a scattering of coconuts, no two alike. I break open the hard shell of one and scrape out the meat.

On my land is a small shrine to the gods where morning and evening I set flowers, burn incense and cleanse myself with water before offering up prayers. The aroma of sandalwood is bracing.

Later, as night falls and the studio grows still, I step into the garden to light candles by the stone statues there. Candle glow only deepens the surrounding black. In the pitch-dark of night the senses are heightened and even vision grows more acute. The cries and murmurs of birds and animals, the thuds of falling coconuts, all form part of the unalterable web of the rhythms in nature that lie beyond human control.

Two seasons alternate on the island, dry and rainy. Sunlight is lavish year-round, and vegetation grows thick. Late at night when the moon is full, large dewdrops hang from the tips of leaves. Gazing at them, I sense the overflowing vitality in plants that sustains so many of the living things on this planet. Colors born from the plant world carry something of the essence of life. It is that vital life force that I work with; that is why I take such pains with the materials for my quilts.

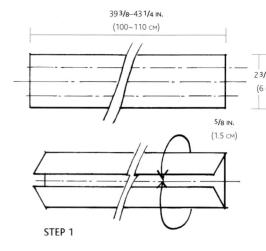

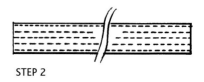

STEP 1: To make the cords, prepare a cloth 2 3/8 in. (6 cm) wide and 39 3/8–43 1/4 in. (100–110 cm) long, and fold in quarters as in the diagram.

STEP 2: Stitch by machine.

MATERIAL: Bamboo-dyed silk organdy
TECHNIQUE: Braiding

NOTE: As necessary, fasten with pins or staples as you go.

MORE PATTERNS CAN BE FOUND ON PP. 121–22.

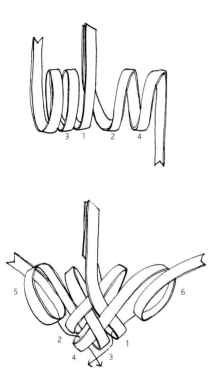

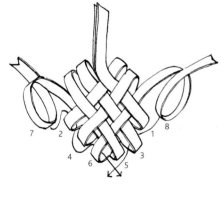

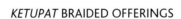

The quilts I create incorporate textures that I have absorbed from overseas. They are woven with contrasting textures of other cultures, shaped by innumerable differences in ethnicity, customs, lifestyle and values. In the early years it often happened that work I had done in Bali proved overpowering and somehow out of place when I took it back to Kyoto; over time I realized that I needed to find the right balance between what I was learning in Bali and my own natural aesthetic and cultural influences. Basically I began to prune away elements that were not strictly in line with my own aesthetic. This process of cutting away has been enlivening. I often feel that I am trying to cut down to the marrow of my work and also, since I work with plants and other natural materials, of life itself.

My work in the Grass House Studio near the equator thus gets close to the bone; it is, literally and figuratively, a start from "zero." Setting up my studio in a foreign culture has been a way of getting closer to fundamentals.

KETUPAT BRAIDED OFFERINGS

Balinese women's lives are rich with traditions of creating beautiful decorative art for the most down-to-earth purposes. One example is *ketupat*, the art of braiding fresh young coconut leaves into all sorts of three-dimensional shapes (see photo, page 67). The women's handiwork produces delicate pieces of incredible artistry. These are used as offerings or as containers for rice on festive occasions. Rice is steamed in them for about an hour, during which time the fragrance of the leaves flavors the rice.

I tried my hand at *ketupat* by cutting silk organdy cords, then stitching them and braiding them together. Velvet also works well. If you prefer, you can use ready-made ribbon, adjusting the width for variety. Slightly stiffer ribbon is easier to handle and gives better results.

I like to make Christmas boxes out of red cloth and shiny metallic cloth and use them to wrap small presents. Or fill a braided container with herbs and spices and hang it in your closet or wear it as a necklace.

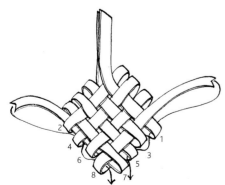

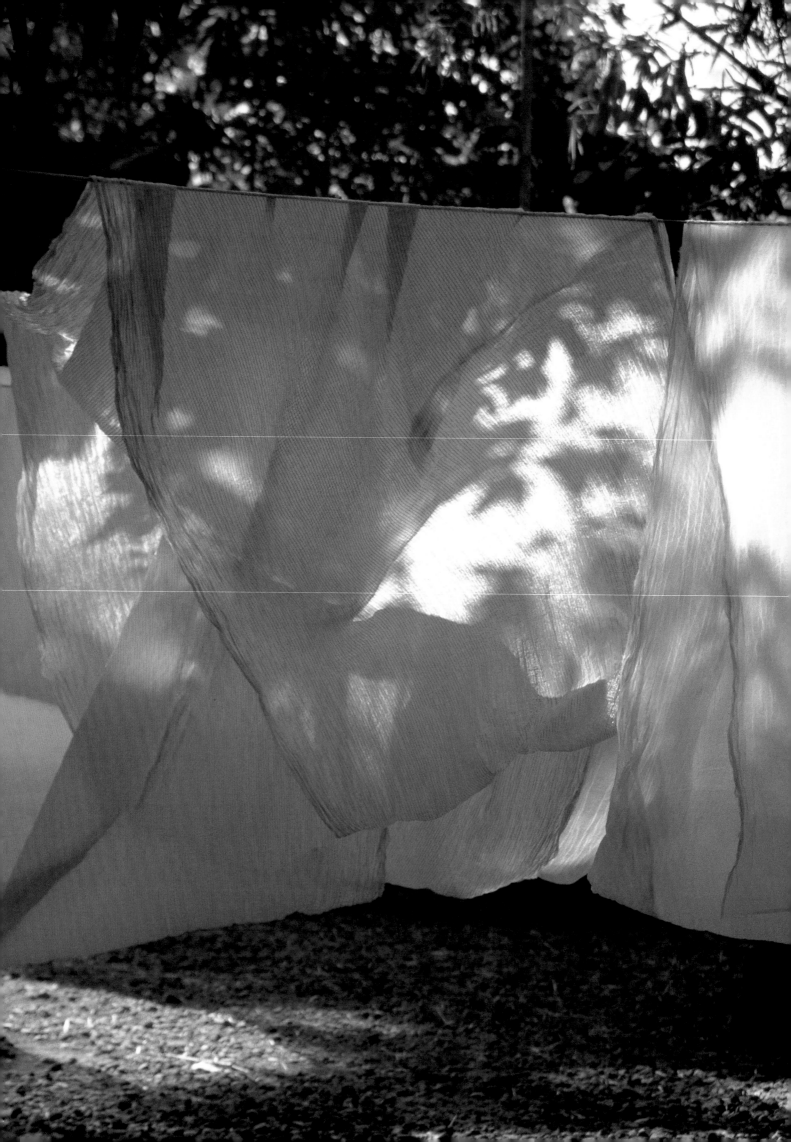

I had been making quilts for years from fabrics that I dyed myself with natural dyes when I had a kind of awakening. It was during an exhibition where my work was being shown together with that of a lacquerware artist. When I looked at his pieces, with their simple and beautiful form and their quiet sheen achieved by applying lacquer in careful layers, I thought, what kind of fabric could I make that would have that same sense of power? Finally it came to me, I wanted to find a natural dye that would dye cloth white.

In the field of natural dyes, white was the one color that no one knew how to obtain. For me white was suggestive of the *fusuma* and *shoji* sliding doors used to separate Japanese-style rooms, as well as the traditions of *sumi* ink drawings and calligraphy and even the white sand of Zen gardens.

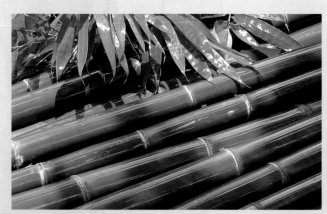

I began to experiment with all the plants, roots and trees around my studio in Bali. Nothing worked. Finally I hit upon the idea of trying bamboo. I boiled bamboo to draw out the essence and added silk cloth and cooked it for several hours, but when I took the fabric from the dyebath it was a dull light brown. I thought it was a failure, but hung it out anyway to dry in the rich Bali sunlight. Two or three hours later the cloth had been transformed. It was as if the silk was a prism sparkling with colors like pink, yellow and green. It was a white with depths, a powerful seashell white.

Bamboo is a strange combination of tree and grass. Its cylindrical shape, its emptiness and its nodes all contribute to its strength. Even in tropical jungles, where competition for survival is fierce, it grows luxuriantly. It stands vertical but has the pliancy to bend in the wind, which makes it still more resilient.

The best bamboo for dyeing are young poles that look solid and strong. The best time to gather them is early morning. I cut down about ten bamboo poles that are about sixteen feet (five meters) high, remove the leaves and branches and wash the trunks. Then I chop them up for maximum exposure to the water and let them boil for two hours before I remove the lid and check the color of the water. If it has deepened to a pale tea color, I remove the bamboo and strain the steaming solution through several layers of cloth. Once it has cooled enough for me to put my hand in, I carefully immerse fabric in the dye solution and swish it around, slowly, for

LEFT: Bamboo-dyed nylon drying in the Bali sunlight.

about two hours. After checking to see if the dye has taken, I take out the fabric, rinse it thoroughly in running water and hang it to dry in an airy space where the sunlight filters through leaves. (Sunshine and breezes are necessary parts of the dyeing process, since they bring out the true color.) The dyeing, rinsing and drying process needs to be repeated two or three times over several days for each piece of fabric, each time with new bamboo dye.

Several stalks of bamboo are needed to dye one eleven-yard (ten-meter) length of silk. The fresher the bamboo, the better the result, so I have to be careful not to spend too much time on preparation.

Bamboo-dyed white contains the richness of all tropical colors, and it *stays* white. The material is as practical as it is beautiful: I soon found that coffee stains and the like easily wash out of bamboo-dyed silk. Scientific studies have shown too that silk dyed three times in bamboo dye absorbs far more ultraviolet rays than undyed silk, yet another boon (see the graph opposite).

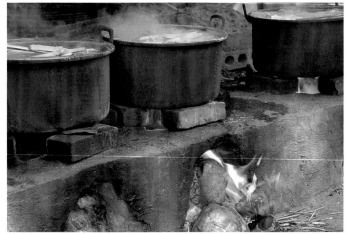

Later I searched further, for materials that would be readily available outside Asia, and I found that dyeing silk in corn husks and cornsilk produced the same kind of luminous white that I had gotten with bamboo. Dyeing with corn husks can be done easily in the kitchen; just boil the husks and cornsilk vigorously in a pan for about two hours, pour the liquid through a strainer, and proceed. For best results use commercially available white silk—which I find absorbs natural dye best of all—or undyed silk.

By all means try making one of these quilts for yourself. I guarantee you will find that a quilt of naturally dyed white silk feels vastly different than one made of cotton.

THIS PAGE AND FAR RIGHT: Cutting, boiling and straining bamboo to use in dyeing silk. RIGHT: Patchwork of samples of many different bamboo-dyeing sessions over the years; the variations are produced by the strength of the dye and the texture of the silk.

ABSORPTION OF ULTRAVIOLET RAYS BY HANDWOVEN SILK, FROM CULTIVATED SILKWORMS, DYED IN BAMBOO

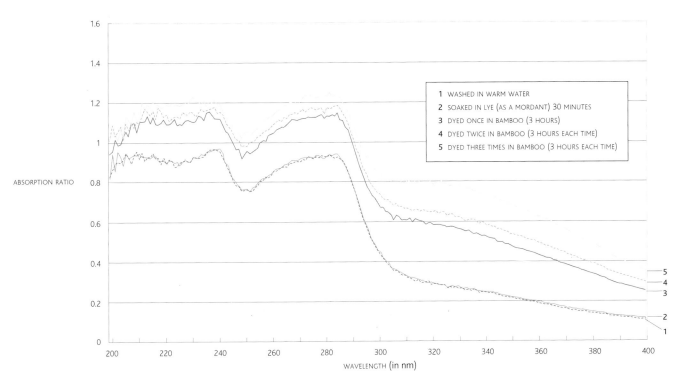

ABSORPTION RATIO

WAVELENGTH (in nm)

1 WASHED IN WARM WATER
2 SOAKED IN LYE (AS A MORDANT) 30 MINUTES
3 DYED ONCE IN BAMBOO (3 HOURS)
4 DYED TWICE IN BAMBOO (3 HOURS EACH TIME)
5 DYED THREE TIMES IN BAMBOO (3 HOURS EACH TIME)

EXAMINED BY THE GANGOJI INSTITUTE FOR RESEARCH INTO CULTURAL PROPERTY

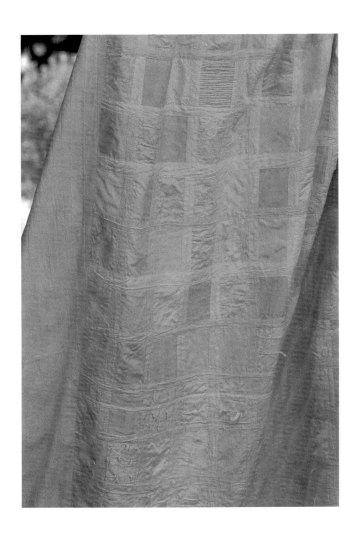

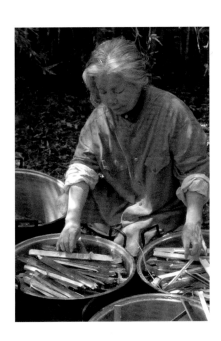

The original idea for my Embossed Quilts came from embossed handmade *washi* paper. In the world of white *washi*, papermakers sometimes emboss the surface or use other techniques to increase the effect of unevenness and bring out the texture of the paper. I tried converting embossing techniques to quiltwork.

The material is bamboo-dyed white. Cloth dyed with natural dye is essentially different from cloth dyed with chemical dye. When using natural dye, it doesn't seem right to mark in quilting and basting lines with a pencil. I prefer to pin threads over the material, decide where to baste and then mark the cloth with white basting thread, as shown on pages 76–77, Step 2. This is a useful technique to know about; you can use it with any fabric too precious to draw lines on.

This quilt is made in three sections and joined with cord piping. Note that the fine quilting stitches will cause the material to shrink by about 4 inches (10 centimeters).

Large quilts can be stitched in sections, which makes it possible to sew quilts of any size on even a small sewing machine.

For another view of this quilt, please see page 9.

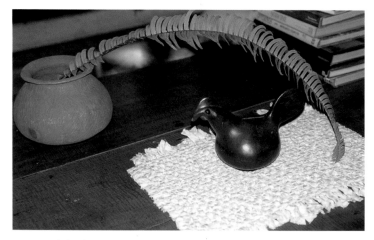

ABOVE: Braided and Woven Table Mat of bamboo-dyed white silk **(INSTRUCTIONS FOR MAKING CAN BE FOUND ON P. 123)**. RIGHT: Embossed Quilt: "White Repose."

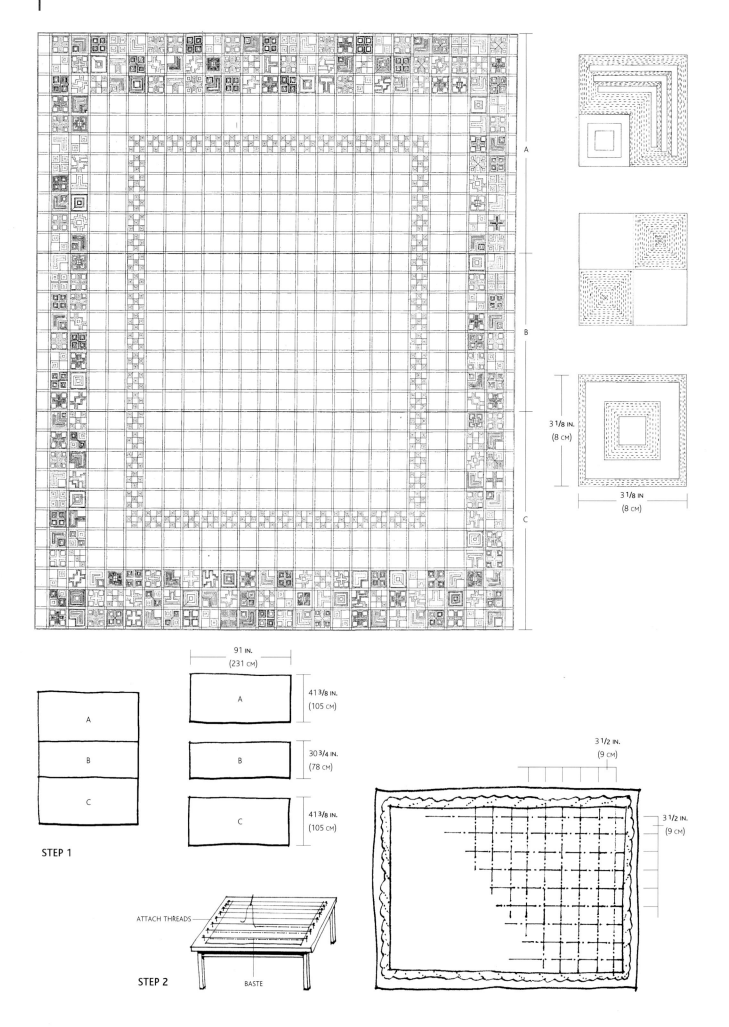

A

B

3 1/8 IN.
(8 CM)

C

3 1/8 IN
(8 CM)

91 IN.
(231 CM)

| A | 41 3/8 IN. (105 CM) |

| B | 30 3/4 IN. (78 CM) |

| C | 41 3/8 IN. (105 CM) |

A

B

C

STEP 1

ATTACH THREADS

STEP 2 BASTE

3 1/2 IN.
(9 CM)

3 1/2 IN.
(9 CM)

STEP 3

START

3/8 IN.
(1 CM)

3 1/2 IN.
(9 CM)

3/8 IN.
(1 CM)

3 1/2 IN.
(9 CM)

3/8 IN.
(1 CM)

3 1/2 IN.
(9 CM)

3/8 IN.
(1 CM)

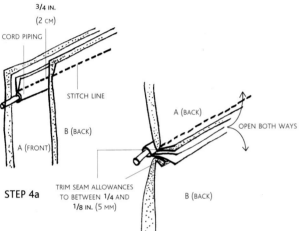

3/4 IN.
(2 CM)

CORD PIPING

STITCH LINE

B (BACK)

A (FRONT)

A (BACK)

OPEN BOTH WAYS

STEP 4a

TRIM SEAM ALLOWANCES
TO BETWEEN 1/4 AND
1/8 IN. (5 MM)

B (BACK)

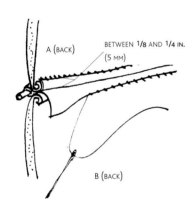

A (BACK)

BETWEEN 1/8 AND 1/4 IN.
(5 MM)

B (BACK)

STEP 4b

MATERIAL: Bamboo-dyed silk

TOP CLOTH: Silk 1 yd. 7 1/4 in. x 9 yds. 30 1/2 in. (110 cm x 9 m; this amount includes bias tape cord piping and bias tape)

BATTING: Wool

BACKING: Silk (slightly larger than top cloth)

TECHNIQUE: Machine quilting

COMPLETED SIZE: 84 5/8 x 102 3/8 in. (215 x 260 cm)

STEP 1: First cut the material into three sections—A, B and C—as shown (sizes given include the seam allowance).

STEP 2: Insert pins along opposite sides of a board at 3 1/2-in. (9-cm) intervals and attach threads across the board from one pin to the pin directly opposite. Insert the fabric between the rows of pins and baste in marking lines across from one pin to another. Turn the fabric 90° and sew again, to make a checkerboard pattern. Layer the surface, batting and backing; secure with pins.

STEP 3: Add machine-quilting stitches along lines 1/4 in. (5 mm) to either side of the checkerboard lines, and take basting out. Following the quilting block sketches and the overall pattern, quilt inside the squares. Finish sections A, B and C. Referring to the diagram at top right, begin at the outside and stitch continuously inside the square without cutting the thread. At the beginning and end leave about 3 in. (7.5 cm) of thread free. Draw the top thread through the material and knot it with the bottom thread. Pass the end of this thread by hand through a needle and draw the knot back down through a stitch hole, between the layers.

STEP 4a: Join A and B as shown. As cord piping, insert a 1 5/8-in. (4-cm)–wide bias tape containing a narrow cord between A and B, and stitch together (the cord piping will be 3/4 in. / 2 cm wide). Trim the seam allowances of A and B to the same size, between 1/4 and 1/8 in. (5 mm).

STEP 4b: Roll back the seam allowances of the cord piping and blindstitch.

STEP 5: Attach bias tape cord piping and bias tape around the edge. Trim the seam allowances, leaving 3/8 in. (1 cm). Fold the bias tape over and blindstitch in back at a width of 3/8 in. (1 cm).

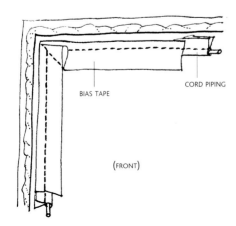

BIAS TAPE

CORD PIPING

(FRONT)

STEP 5

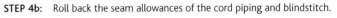

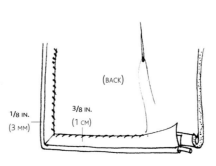

(BACK)

1/8 IN.
(3 MM)

3/8 IN.
(1 CM)

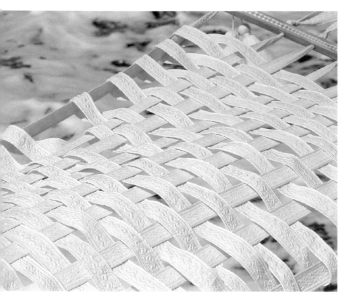

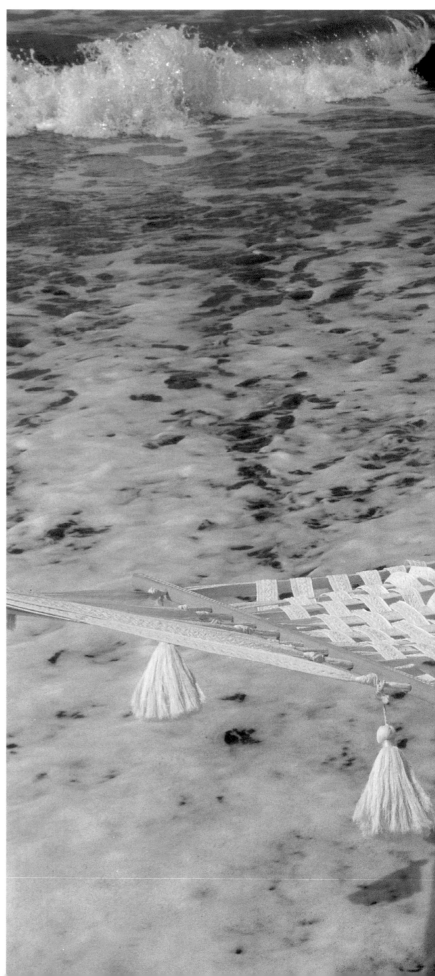

Silk Ribbon Hammock. Bamboo-dyed silk.

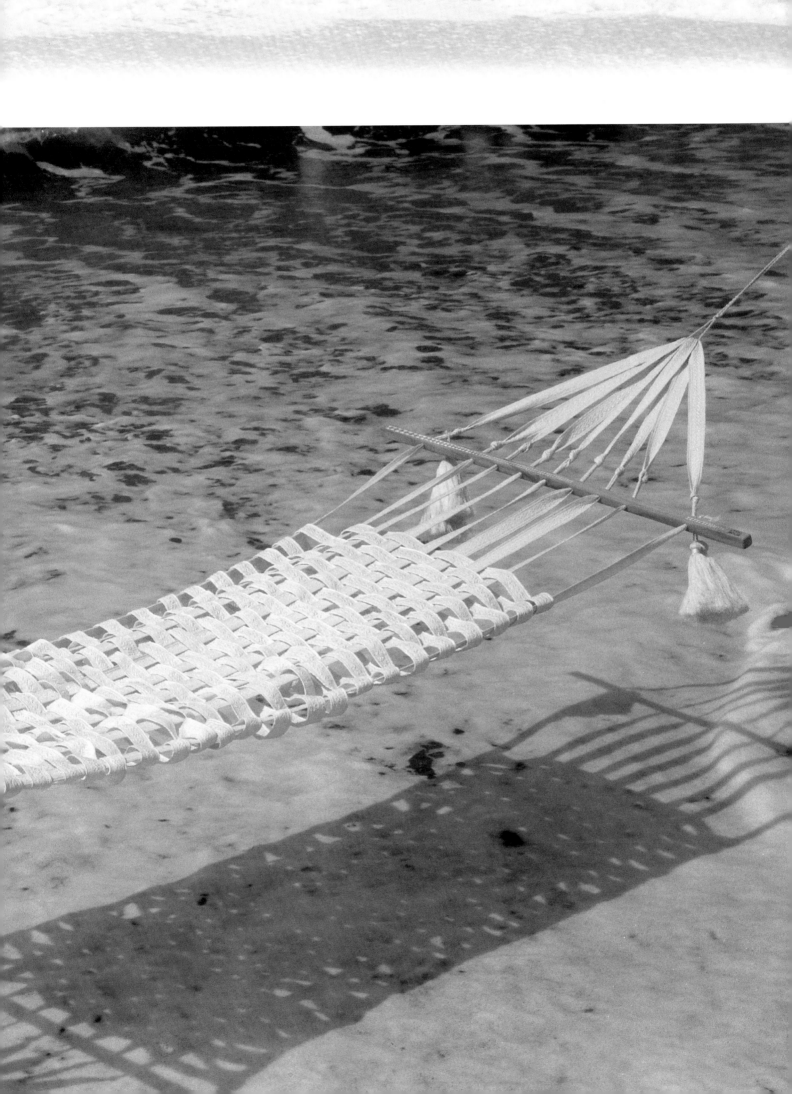

A hammock always seems to me like the height of luxury, and particularly so with this one made of white quilted silk.

This hammock is not hard to make. You just need two wooden poles and some long pieces of fabric tape. You can use an array of bright colors, if you like; since the pieces are quite long, you might try joining various colors in one tape for a unique kaleidoscopic effect. This hammock can be used in a child's room to hold a collection of stuffed animals or cushions, or at Christmastime as a unique way of displaying gift-wrapped presents. I used teak, but any kind of wood can be used. Substituting tree branches or even lengths of bamboo for the poles gives a more natural, rugged effect.

Someday I'd like to make some felt ribbons from wool of many different colors, put some machine-stitching into them, and use them to make a hammock with a completely different kind of feeling.

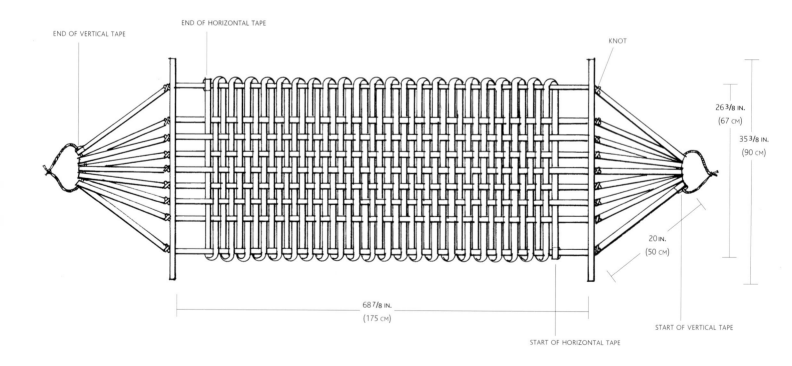

END OF HORIZONTAL TAPE

END OF VERTICAL TAPE

KNOT

26 3/8 IN. (67 CM)

35 3/8 IN. (90 CM)

20 IN. (50 CM)

68 7/8 IN. (175 CM)

START OF VERTICAL TAPE

START OF HORIZONTAL TAPE

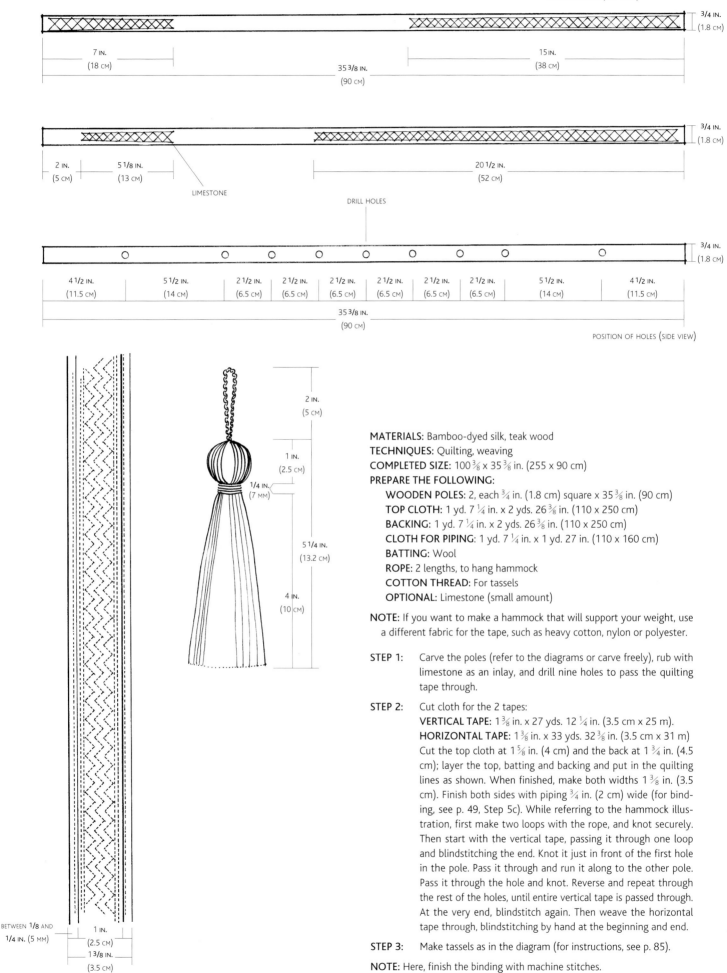

WOOD CARVING (TOP VIEW)

7 IN.
(18 CM)

15IN.
(38 CM)

35 3/8 IN.
(90 CM)

3/4 IN.
(1.8 CM)

3/4 IN.
(1.8 CM)

2 IN.
(5 CM)

5 1/8 IN.
(13 CM)

20 1/2 IN.
(52 CM)

LIMESTONE

DRILL HOLES

3/4 IN.
(1.8 CM)

4 1/2 IN.
(11.5 CM)

5 1/2 IN.
(14 CM)

2 1/2 IN.
(6.5 CM)

2 1/2 IN.
(6.5 CM)

2 1/2 IN.
(6.5 CM)

2 1/2 IN.
(6.5 CM)

2 1/2 IN.
(6.5 CM)

2 1/2 IN.
(6.5 CM)

5 1/2 IN.
(14 CM)

4 1/2 IN.
(11.5 CM)

35 3/8 IN.
(90 CM)

POSITION OF HOLES (SIDE VIEW)

2 IN.
(5 CM)

1 IN.
(2.5 CM)

1/4 IN.
(7 MM)

5 1/4 IN.
(13.2 CM)

4 IN.
(10 CM)

BETWEEN 1/8 AND
1/4 IN. (5 MM)

1 IN.
(2.5 CM)

1 3/8 IN.
(3.5 CM)

MATERIALS: Bamboo-dyed silk, teak wood
TECHNIQUES: Quilting, weaving
COMPLETED SIZE: 100 3/8 x 35 3/8 in. (255 x 90 cm)
PREPARE THE FOLLOWING:
 WOODEN POLES: 2, each 3/4 in. (1.8 cm) square x 35 3/8 in. (90 cm)
 TOP CLOTH: 1 yd. 7 1/4 in. x 2 yds. 26 3/8 in. (110 x 250 cm)
 BACKING: 1 yd. 7 1/4 in. x 2 yds. 26 3/8 in. (110 x 250 cm)
 CLOTH FOR PIPING: 1 yd. 7 1/4 in. x 1 yd. 27 in. (110 x 160 cm)
 BATTING: Wool
 ROPE: 2 lengths, to hang hammock
 COTTON THREAD: For tassels
 OPTIONAL: Limestone (small amount)

NOTE: If you want to make a hammock that will support your weight, use a different fabric for the tape, such as heavy cotton, nylon or polyester.

STEP 1: Carve the poles (refer to the diagrams or carve freely), rub with limestone as an inlay, and drill nine holes to pass the quilting tape through.

STEP 2: Cut cloth for the 2 tapes:
VERTICAL TAPE: 1 3/8 in. x 27 yds. 12 1/4 in. (3.5 cm x 25 m).
HORIZONTAL TAPE: 1 3/8 in. x 33 yds. 32 3/8 in. (3.5 cm x 31 m)
Cut the top cloth at 1 5/8 in. (4 cm) and the back at 1 3/4 in. (4.5 cm); layer the top, batting and backing and put in the quilting lines as shown. When finished, make both widths 1 3/8 in. (3.5 cm). Finish both sides with piping 3/4 in. (2 cm) wide (for binding, see p. 49, Step 5c). While referring to the hammock illustration, first make two loops with the rope, and knot securely. Then start with the vertical tape, passing it through one loop and blindstitching the end. Knot it just in front of the first hole in the pole. Pass it through and run it along to the other pole. Pass it through the hole and knot. Reverse and repeat through the rest of the holes, until entire vertical tape is passed through. At the very end, blindstitch again. Then weave the horizontal tape through, blindstitching by hand at the beginning and end.

STEP 3: Make tassels as in the diagram (for instructions, see p. 85).

NOTE: Here, finish the binding with machine stitches.

With their easy blend of color, texture, visual interest and comfort, cushions draw together all the furnishings in a room. The cushions I make are decorative as well as functional, and each new pattern tends to suggests still more ideas. I put fine pintuck work on handwoven silk, creating a flat side and a textured side; by including ornamental features made from a variety of materials—braid, silver, pearls, tassels—the softness of the silk is emphasized. When you pick up one of these cushions, the fringe sways, giving a luxurious feeling. Hints for creativity are everywhere: shells on the beach, bits of wood or silver in interesting shapes, beads from an old necklace, curios found while traveling—all can be added to a collection that you turn to when you are looking for something new and different.

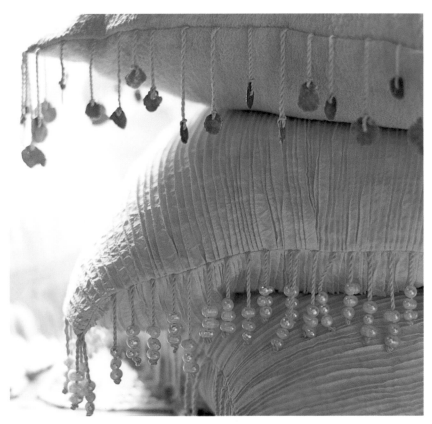

Ornamented Cushions. Bamboo-dyed silk, silver, pearls.

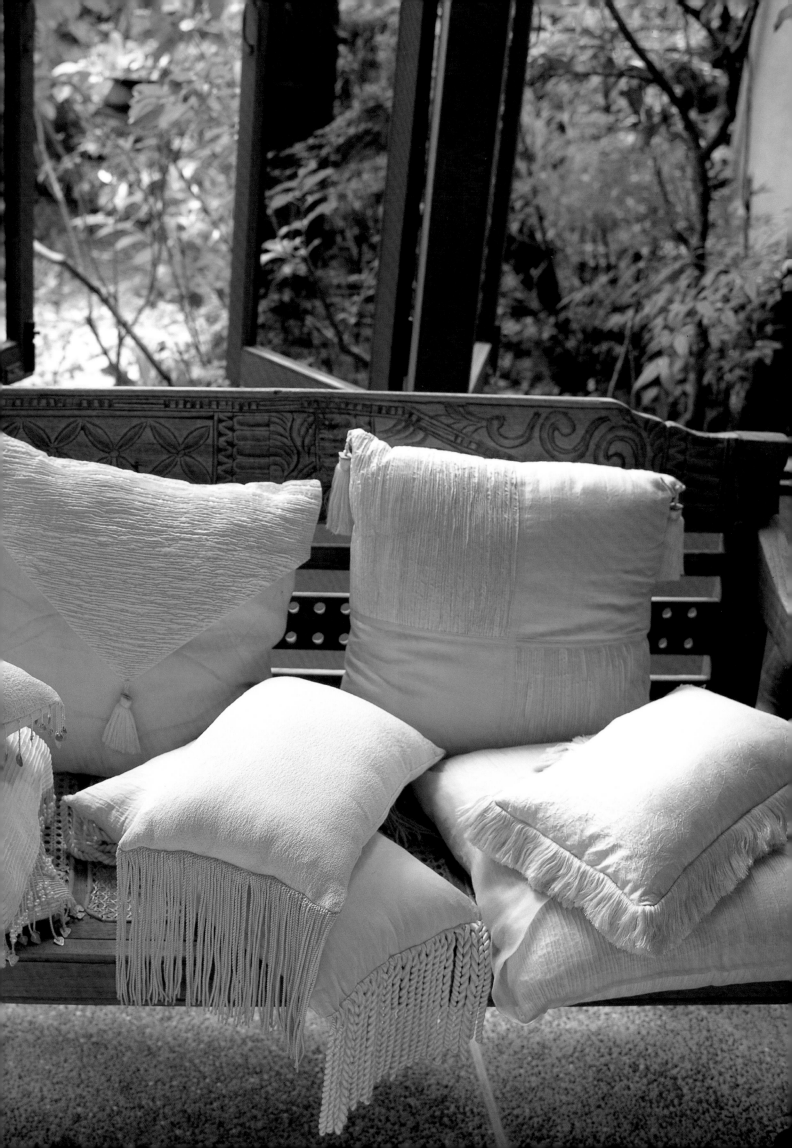

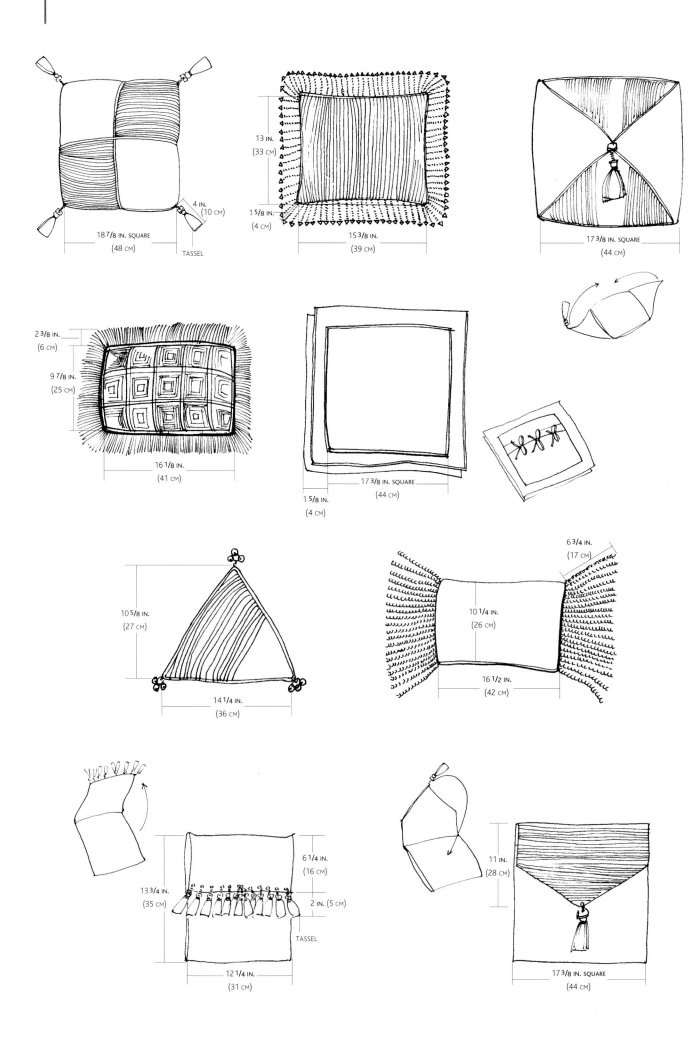

18 7/8 IN. SQUARE
(48 CM)

4 IN.
(10 CM)

TASSEL

13 IN.
(33 CM)

1 5/8 IN.
(4 CM)

15 3/8 IN.
(39 CM)

17 3/8 IN. SQUARE
(44 CM)

2 3/8 IN.
(6 CM)

9 7/8 IN.
(25 CM)

16 1/8 IN.
(41 CM)

17 3/8 IN. SQUARE
(44 CM)

1 5/8 IN.
(4 CM)

10 5/8 IN.
(27 CM)

14 1/4 IN.
(36 CM)

6 3/4 IN.
(17 CM)

10 1/4 IN.
(26 CM)

16 1/2 IN.
(42 CM)

6 1/4 IN.
(16 CM)

13 3/4 IN.
(35 CM)

2 IN. (5 CM)

TASSEL

12 1/4 IN.
(31 CM)

11 IN.
(28 CM)

17 3/8 IN. SQUARE
(44 CM)

STEP 1

STEP 2

MATERIAL: Bamboo-dyed silk
TASSELS: Silk thread
FRINGE: Silk thread, silver, pearls
TECHNIQUE: Pintuck work, quilting

TASSEL

STEP 1: Prepare the proper amount of thread depending on the planned size of the tassel.

STEP 2: Bind tightly in the middle.

STEP 3: There are two ways of proceeding; see the diagrams. (For A, put a small ball of cotton or other filling in the center and wrap. For B, cinch in the center, without filling, and pull threads down. Cinch once more, lower. Then pull all the strings back up and cinch again, so that the tassel hangs from the first cinching threads.)

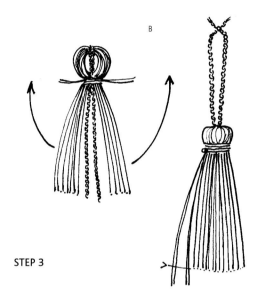

A

B

STEP 3

FRINGE A

FRINGE B

FRINGE C

FRINGE

FRINGE A: Take silver beads and flatten them with a hammer to create all sorts of shapes. Drill a hole for the thread.

FRINGE B: Cut thin silver, copper or metal plate into triangles and round the corners with scissors; drill a hole in each and thread.

FRINGE C: Thread pearls.

FOR PINTUCK WORK, PINCH FOLDS INTO FABRIC AT VARYING INTERVALS, AND STITCH 1/16 IN. (2 MM) FROM THE FOLD.

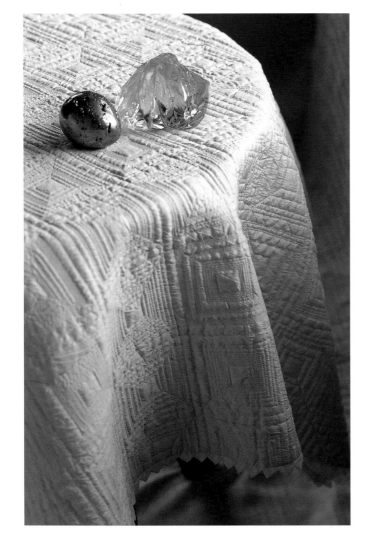

Baby Quilts in various patterns. Bamboo-dyed silk.

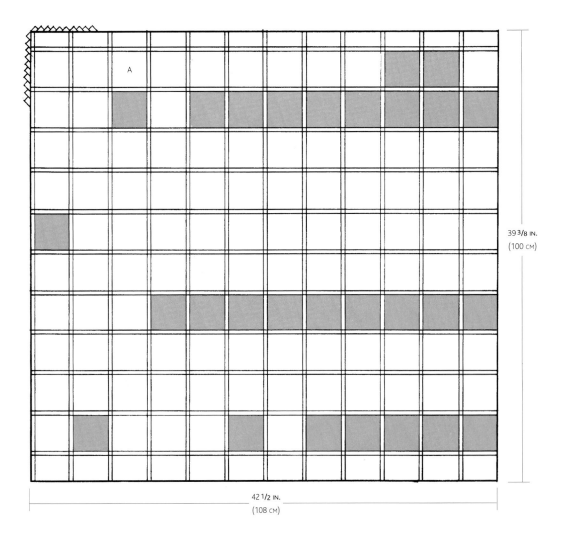

A

39 3/8 IN.
(100 CM)

42 1/2 IN.
(108 CM)

Pattern A

Pattern B

These baby quilts are striking and have strong, clean lines, yet they are basically not difficult to make.

Start by adding square quilting lines to a piece of material 1 yard 7 ¼ inches (110 centimeters) square, adjusting the overall form. Then freely add details of the quilting motif within the regularly marked-off squares. Placing tiny folded triangles around the edges gives a visually soft and pleasing effect.

These quilts can be stitched by hand or machine; each method has its own beauty. When machine quilting, handle the thread with extra care at the start and finish. Avoid cutting the quilt lines; best are designs that can be completed in one continuous, unbroken line of stitching. Since the entire surface is quilted, depending on the number of stitches you should allow for shrinkage of about 1 ½ to 2 inches (4 to 5 centimeters). Placing small folded triangles (prairie points) around the edges gives a visually soft and pleasing effect.

Framed baby quilts make charming wall decorations for a dining room or other interior.

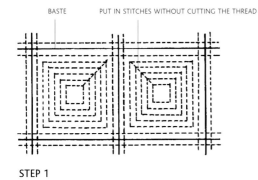

BASTE PUT IN STITCHES WITHOUT CUTTING THE THREAD

STEP 1

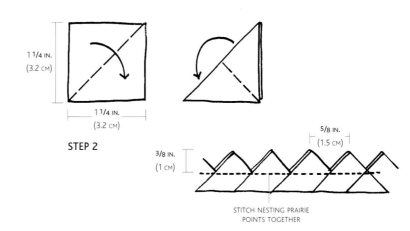

1 1/4 IN. (3.2 CM)

1 1/4 IN. (3.2 CM)

STEP 2

5/8 IN. (1.5 CM)

3/8 IN. (1 CM)

STITCH NESTING PRAIRIE POINTS TOGETHER

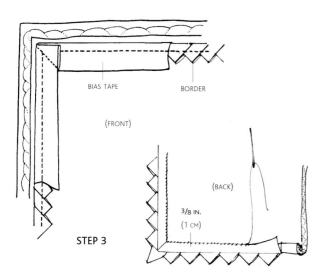

BIAS TAPE

BORDER

(FRONT)

(BACK)

3/8 IN. (1 CM)

STEP 3

MATERIAL: Bamboo-dyed silk
TOP CLOTH: 1 yd. 5 ³⁄₈ in. x 1 yd. 8 ½ in. (105 x 113 cm)
BATTING: Wool
BACKING: 1 yd. 7 ¼ in. x 1 yd. 11 ¼ in. (110 x 120 cm)
EDGING :
 PRAIRIE POINTS: 1 yd. 5 ³⁄₈ in. x 20 in. (105 x 50 cm)
 BIAS TAPE: 1 in. x 4 yds. 9 in. (2.5 x 450 cm)
TECHNIQUE: Machine quilting
COMPLETED SIZE: 38 ⁵⁄₈ x 41 ³⁄₈ in. (98 x 105 cm)

STEP 1: Prepare a top cloth, a batting and a backing. Do 3 ½-in. (9-cm) checkerboard basting of marking lines as shown on p. 77, Steps 2–3. Layer the top cloth, batting and backing; quilt patterns A and B as shown on p. 88. To tie off the thread, see p. 77, Step 3.

STEP 2: Make the nesting prairie points.

STEP 3: Attach the prairie points with a bias tape 1 in. (2.5 cm) wide (including seam allowance of ¼ in. /6 mm on each side). Blindstitch the bias tape in back to make a hem and tie off the thread.

NOTE: Dotted and solid lines on the diagrams represent quilting lines.

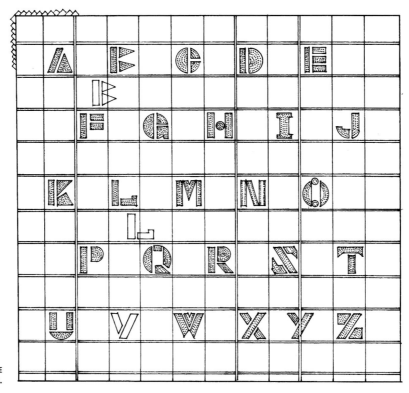

MORE PATTERNS CAN BE FOUND ON P. 124.

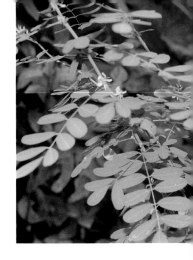

Blessed with year-round sunshine, tropical plants radiate vitality, and the colors produced with them are also full of life.

If the trees planted around my studio go two or three months without a pruning, their branches will steadily grow and intertwine until they block the sunlight. Then, even in the day-time, it's like being deep inside a forest, and shrubs will start to wither and die if I don't trim back the trees overhead. I boil the cut-off branches to extract the color, and use that to dye thread and fabric. After the wood dries it's used once more, as firewood.

I have tried making dyes from every plant and the covering of every fruit at hand: coconut trees and coconuts; jackfruit trees and leaves; mango trees; teak leaves; flame trees, mangosteen, rambutan, jasmine blossoms, bougainvillaea, cloves, and many more. My research has taught me that dye can be extracted from the tiniest plant and from the skin of any fruit; however, because my studio is in the tropics, such materials often attract insects and then spoil. Over the course of human history, out of the substances that could be used as dyestuffs, those with natural resistance to insects were selected: sappanwood for red, *mengkudu* for orange, *soga* for yellow, brown and red. They are also used in Chinese medicine.

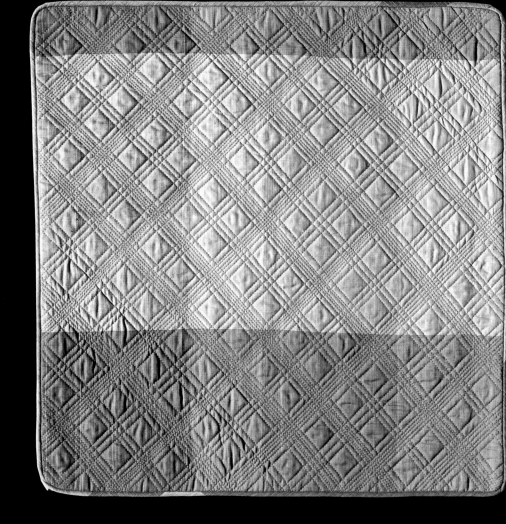

ABOVE LEFT: Leaves of the indigo plant. LEFT (LEFT TO RIGHT): Three types of *soga*: *tagar*, *tinggi* and *jambal*. BELOW LEFT: A flame tree. RIGHT: Cotton quilts made from threads dyed with *soga*. Each 17 ¾ in. (45 cm) square.

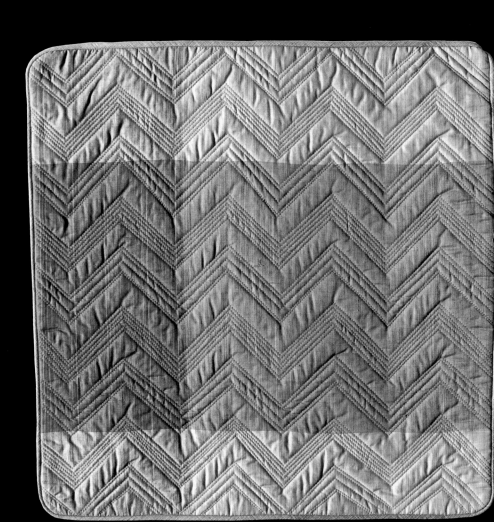

Soga has long been used in the traditional Indonesian dyeing method of batik (see photos page 90). *Soga* is the collective term for *tagar* (yellow), *jambal* (brown) and *tinggi* (red). *Tagar* is from the pith of the tree, and the other two use tree bark soaked in lime. They are used to dye cotton and can be combined to produce a great variety of colors (the quilt, "Coconut Field," pages 98–99, is dyed with *soga*, as is "Ten Thousand–Piece Quilt," pages 12–13).

A dyestuff often used together with *soga* is indigo (*indigofera tinctoria*), a plant of the pea family native to India that also flourishes along the coasts of Indonesia—especially during the long rainy season of December to April—and produces a beautiful indigo blue. The process of indigo dyeing (see page 93) is completely different from the processes used with other plants. Also, indigo dye is indispensable in dyeing fabric black with natural dye.

Once I learned to use natural dye to produce all the primary colors—red, yellow and blue— I began to feel that there was no limit to the combinations and the nuances of shading that were possible.

Climate and plant life vary tremendously around the world, but why not try gathering materials from your own neighborhood—especially plants, nuts, branches, leaves and fruit rind—to dye cloth for the quilts you make? Dyeing cloth for a quilt is easy if you cut it first into manageable widths of 20 to 40 inches (50 centimeters to 1 meter). Unlike chemical dyes, natural dyes yield soft, appealing colors that deepen with time. Using cloth that you yourself have dyed makes you that much more careful with the material, so you are sure to be rewarded with many new ideas for quilt designs as well.

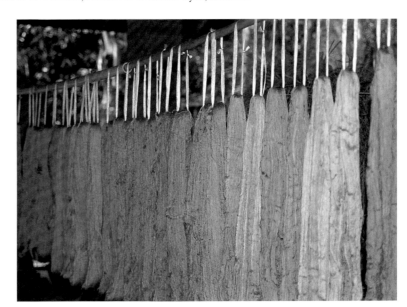

Drying dyed threads in preparation for weaving.

Indigofera tinctoria

INDIGO DYEING IN BALI

STEP 1: Gather 44 pounds (20 kilograms) of indigo leaves early in the morning. Put into a 32-gallon (120-liter) container, add about 24 gallons (90 liters) of water, cover and weight with stones of 55–66 pounds (25–30 kilograms). The next morning (after 21–22 hours), wring out the leaves throughly and remove. There will be about 17.20 gallons (65 liters) of an emerald-green solution remaining.

STEP 2: Remove some of the dye solution with a small container, mix well with 14–17 ounces (400–500 grams) of lime, and return to the original container.

STEP 3: Churn or stir the dye solution up and down for approximately one hour (about 1,200 times). In a few days, the indigo and water will separate. Discard the water on the surface and transfer the indigo settled on the bottom to a different container. Repeat the process until you have about 10 gallons (40 liters) of indigo dye.

STEP 4: To add to the solution, prepare lye (about 13.20 gallons / 50 liters), 5 banana clusters weighing 22 pounds (10 kilograms) to aid in fermentation (4 of *kayu* bananas and 1 of *raja* bananas, peeled and crushed), and 11 pounds (5 kilograms) of *tapeh* (fermented tapioca). Mix all together and allow to sit for a week. The mixture will ferment and turn yellow-green. Stir daily.

STEP 5: Gently immerse thread or fabric in the fermented solution to dye it. After wringing well spread it out, exposing the dyed material to the air to oxidize it. The color will change from yellow-green to indigo blue. To deepen the final color, repeat the entire dyeing process. When finished, rinse repeatedly in water.

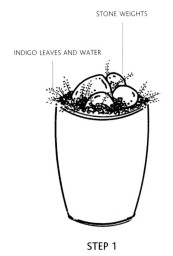

STONE WEIGHTS

INDIGO LEAVES AND WATER

STEP 1

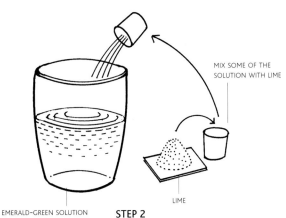

MIX SOME OF THE SOLUTION WITH LIME

EMERALD-GREEN SOLUTION LIME **STEP 2**

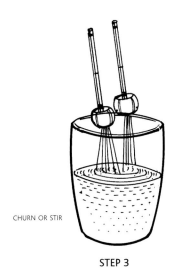

CHURN OR STIR

STEP 3

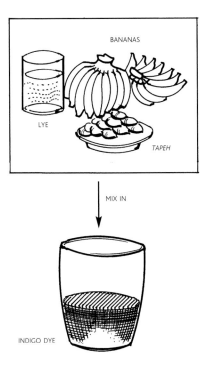

BANANAS

LYE

TAPEH

MIX IN

INDIGO DYE

STEP 4

ENGINEERED QUILT: "GRASS WIND"

I dye the thread with natural dyes and weave the cloth by hand while envisioning and calculating the entire quilt in detail in my mind, and only after that do I make the quilt. A quilt whose existence is engineered from the process of dyeing the thread to the final environment in which the quilt is to be used is what I call an "engineered quilt" or a "Grass House Quilt."

Many Asian societies attach great importance to a single roll of cloth, cutting it so that every piece is used and sewn into one garment (as in the kimono), or simply wrapping one long piece around the body (as with the Indonesian sarong or Indian sari). The bolt of cloth is woven in the exact size needed to make the garment. The engineered quilt uses high technology while remaining close to its roots in these Asian traditions.

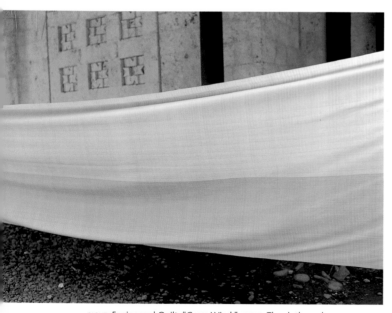

RIGHT: Engineered Quilt: "Grass Wind." ABOVE: The cloth used to make this quilt.

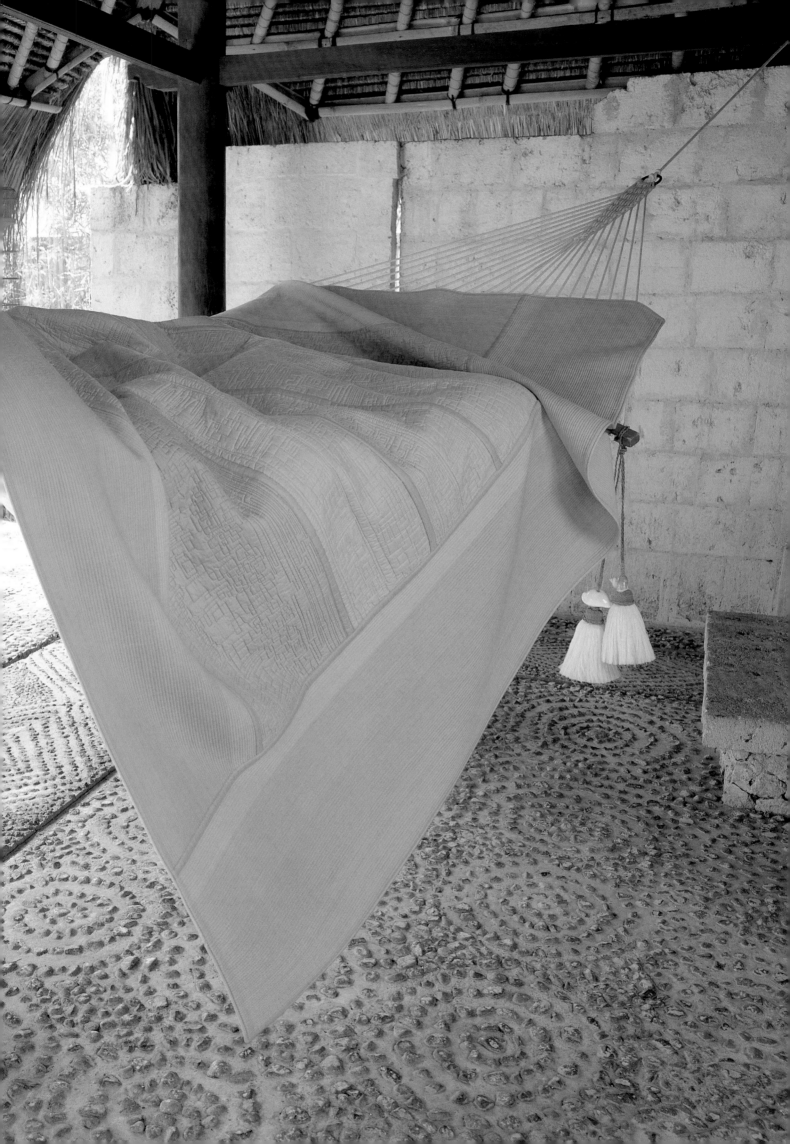

Every step of the process is time-consuming, so even the smallest bit of finished cloth is precious. The cloth should be cut as little as possible, and it should be woven so as to provide interest and balance when the quilt is assembled. It can be returned eventually to its original form. I have experimented a great deal and come up with a number of styles; for example, to make a quilt with large vertical stripes, I change the gradation of the weft strands every 65 feet (20 meters), which nicely coordinates the colors. Every strand of naturally dyed yarn or thread is a subtly different color because of the dyeing process used. When dyeing cotton thread, I first soak it in *gojiru* (a paste made by soaking soybeans in water overnight and then pureeing them) to give it protein, which increases its ability to absorb

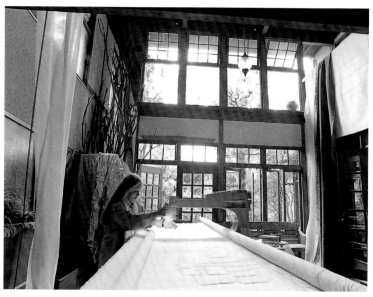

At a large free-motion quilting machine.

natural dye. When the soaked thread is laid out to dry in the intense tropical sun, the rate of absorption of the light is different on the inside and the outside, creating subtle differences and gradations in color.

That's not all. The thread used also has to match the quilt material for the plan to succeed. I make my own thread for machine stitching and dye it to match the quilt I am planning. The gradations in color in the stitching thread add interest and unexpected beauty. I do all my stitching by machine. Analog machines, computerized machines, huge quilting machines with needles that move endlessly back and forth and that can easily finish a 13-foot (4-meter) length: I use different machines for the greatest possible variety. I find that the resulting quilts have an interesting mixture of handmade and machine-made qualities.

The challenge of making my own original materials has enabled me to take a broad view of quiltmaking and to first define problems and then come up with solutions. Engineered quilts make it possible to take artistic control over the entire process, from the step of first coloring the thread.

For this quilt, I used a large free-motion quilting machine. SEE PP. 100–101 FOR INSTRUCTIONS ON MAKING AN ENGINEERED QUILT.

MATERIAL: Cotton dyed with natural dyes
TECHNIQUE: Engineered quilt design; free-motion machine quilting
COMPLETED SIZE: 98 ⅜ in. (250 cm) square

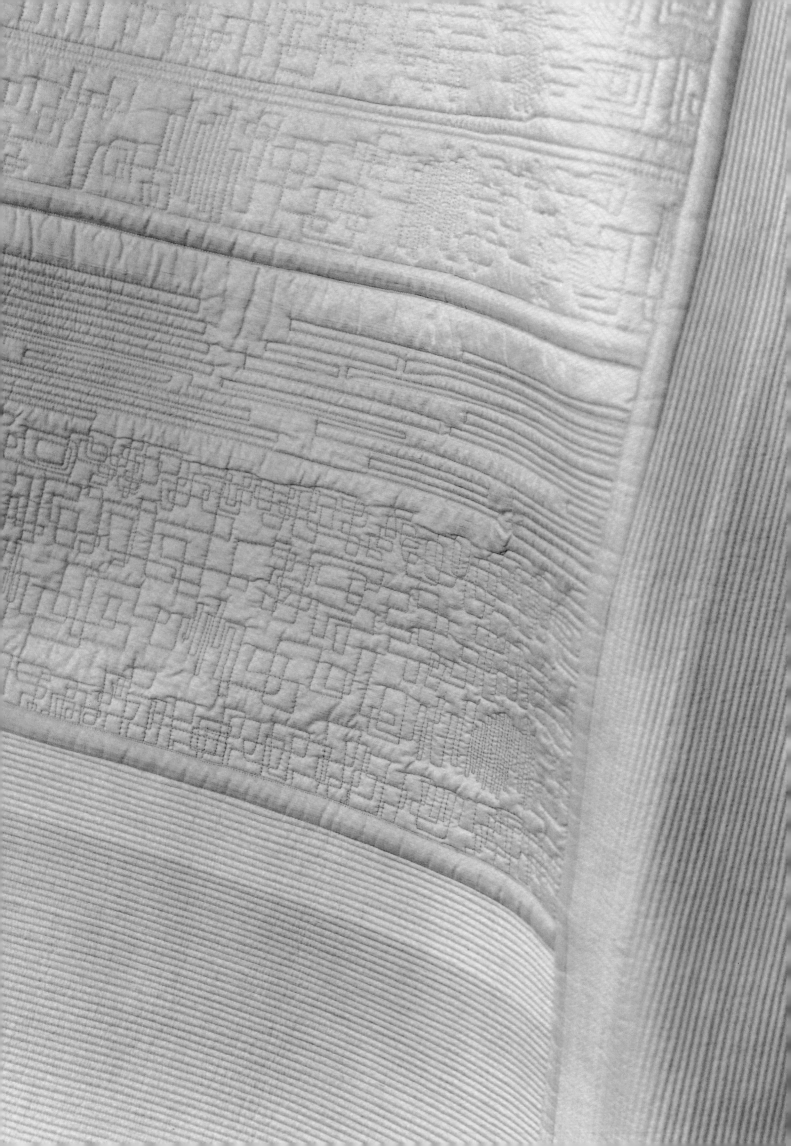

For this quilt I dyed the thread using the Indonesian natural dye *soga*, then wove it into a bold striped design. Every step in the making of this quilt, from conception to completion, was engineered. Out of a cloth measuring 1 yard, 7 ¼ inches x 9 yards (110 x 830 centimeters), I made a quilt measuring 6 ½ x 8 ¼ feet (200 x 250 centimeters). This requires careful planning from the

beginning so that the material for the borders and the center of the quilt is properly arranged on the cloth.

The quilt is made by finishing and then joining the blocks for patterns A, B and C. Dividing the quilt into smaller sections this way makes it easy to do machine quilting and gives good results.

Pattern B uses regular straight lines, while patterns A and C incorporate a contrasting zigzag motif. The fine bias tape where the sections are joined provides an accent.

If you like to weave, try making an engineered quilt using fabric of your own creation. You can also use store-bought material with a bright striped pattern, or plain cloth, combining one thread that matches the cloth with another that contrasts, to enhance the quilting design. There are many different ways to use a single piece of cloth to make a distinctive quilt.

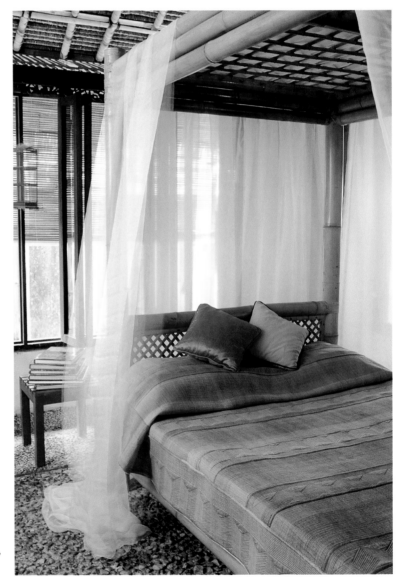

ABOVE AND RIGHT: Engineered Quilt: "Coconut Field."
TOP: The cloth used to make this quilt.

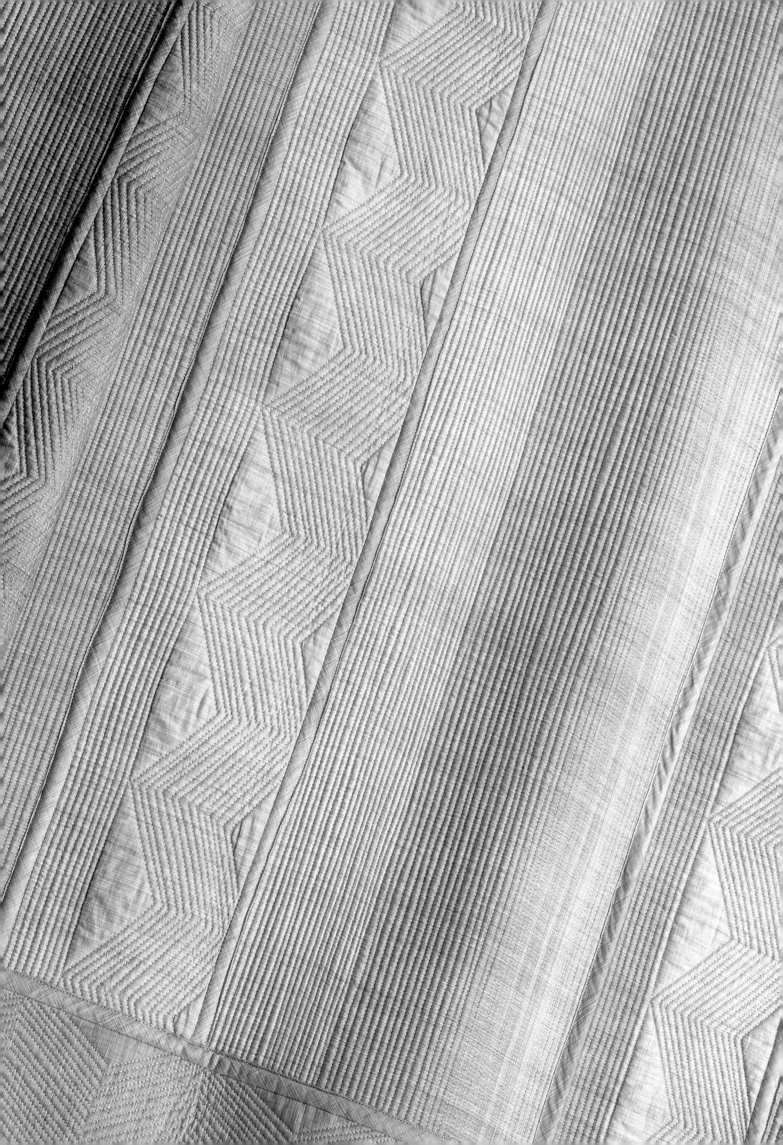

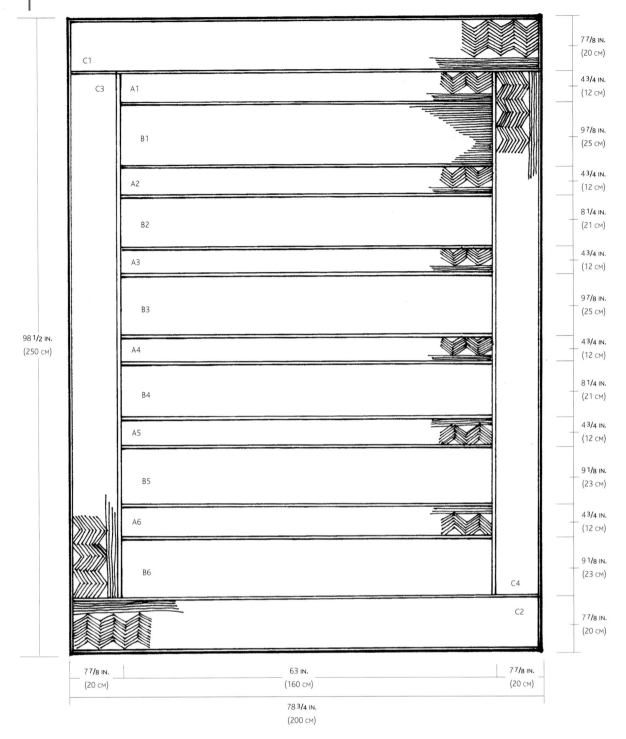

98 1/2 IN.
(250 CM)

77/8 IN. (20 CM)

63 IN. (160 CM)

77/8 IN. (20 CM)

78 3/4 IN.
(200 CM)

7 7/8 IN. (20 CM)

4 3/4 IN. (12 CM)

9 7/8 IN. (25 CM)

4 3/4 IN. (12 CM)

8 1/4 IN. (21 CM)

4 3/4 IN. (12 CM)

9 7/8 IN. (25 CM)

4 3/4 IN. (12 CM)

8 1/4 IN. (21 CM)

4 3/4 IN. (12 CM)

9 1/8 IN. (23 CM)

4 3/4 IN. (12 CM)

9 1/8 IN. (23 CM)

7 7/8 IN. (20 CM)

MATERIAL: Cotton dyed with natural dyes
TOP CLOTH: 1 yd. 7 ¼ in. x 9 yds. (110 cm x 8.3 m)
BATTING: Cotton dyed with natural dyes
BACKING: 1 yd. 7 ¼ in. x 8 yds. 27 in. (110 cm x 8 m)
TECHNIQUE: Engineered quilt design, machine quilting
COMPLETED SIZE: 78 ¾ x 98 ⅜ in. (200 x 250 cm)

STEP 1: Prepare the top cloth, batting and backing (all measurements include the seam allowance). Layer the top cloth over the batting and backing, and quilt patterns A, B and C.

STEP 2: While referring to the overall pattern above, place quilted blocks A and B together, right sides facing, match the outer edges, add a bias tape (1 in./2.5 cm) to the B side and stitch. Trim the seam allowance, fold the bias tape down toward A and stitch. Attach C3 and C4 to the sides and C1 and C2 to the top and bottom with bias tape. With all the bias tape on the C side, fold the seam allowance in and stitch.

STEP 3: Finish with bias tape cord piping and bias tape around the edges (see p. 77, Step 5).

NOTE: The shaded areas of the diagram at far right correspond to the purple accent color areas in the photo of the cloth used to make this quilt (shown on p. 98).

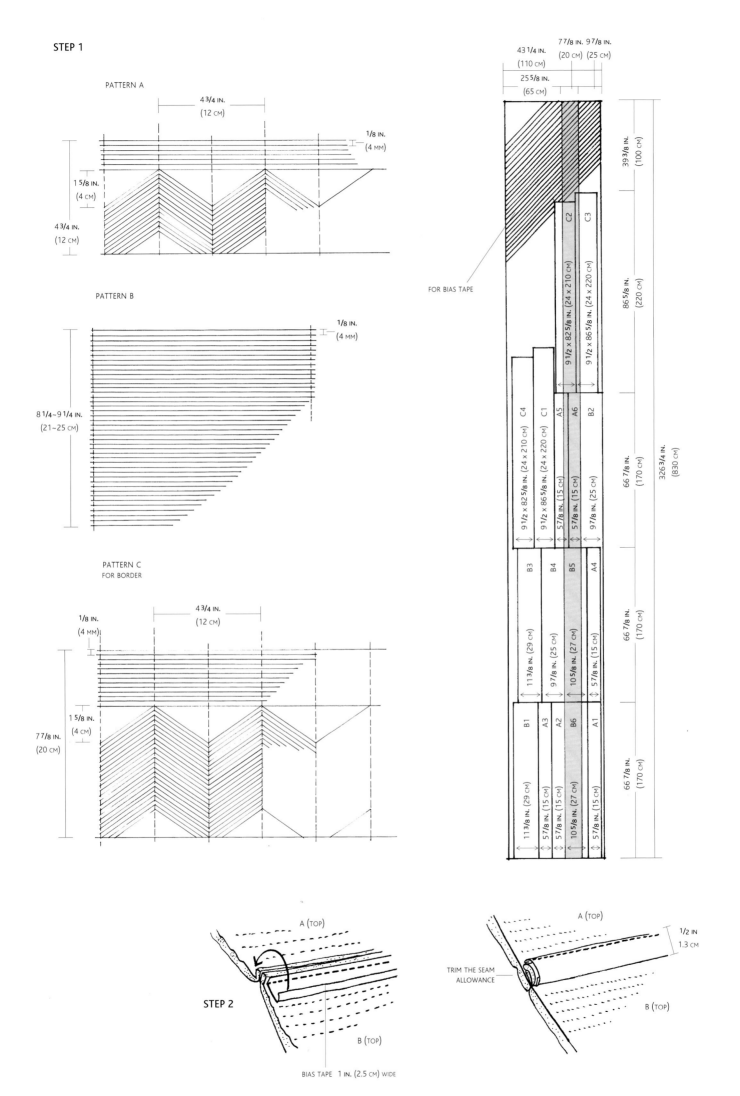

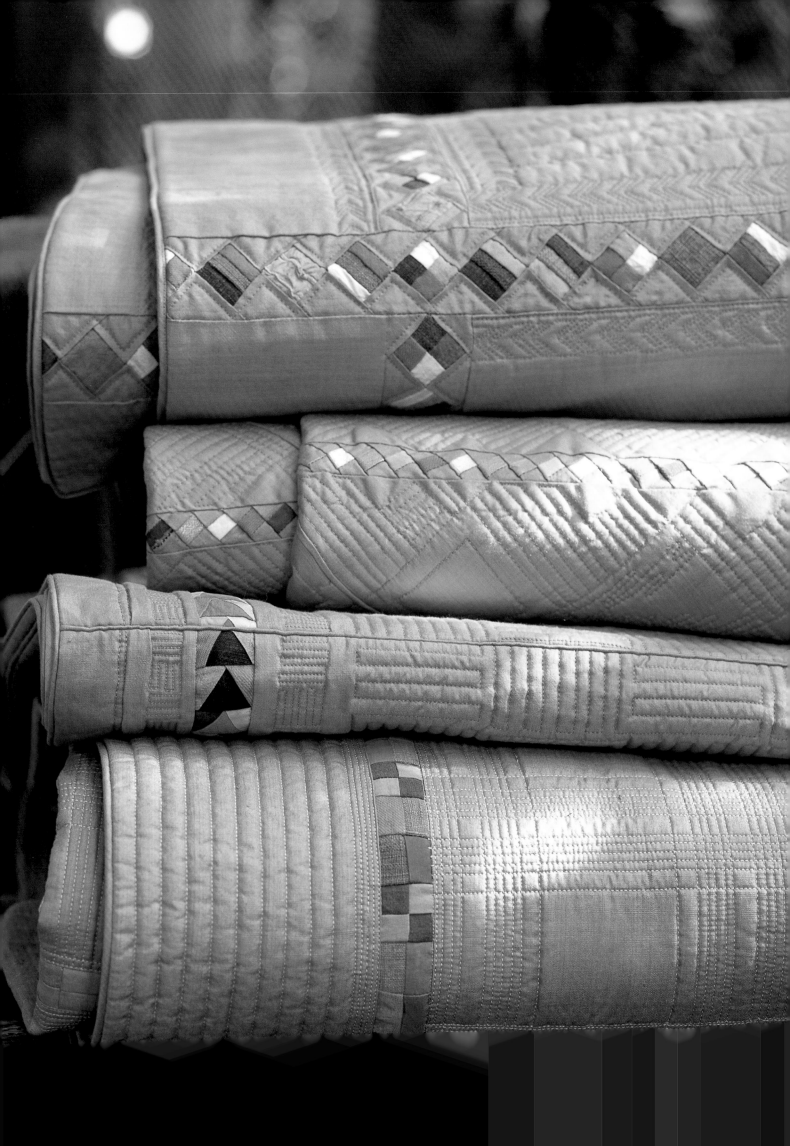

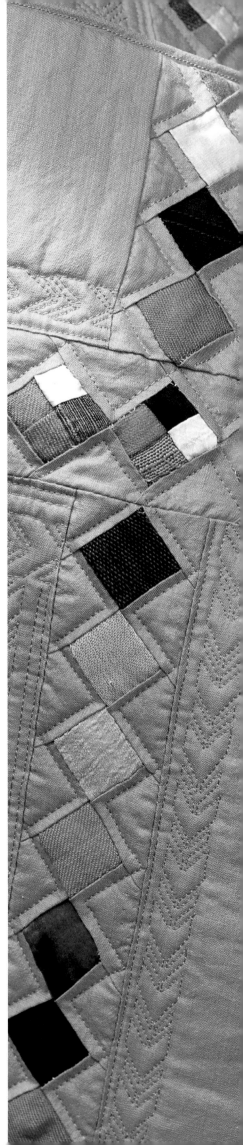

I went on dyeing cloth using colors extracted from all sorts of tropical plants, including tree roots, bark and leaves, until finally I had amassed a collection of fabrics that included cloths of every color under the sun. I picked out my favorite colors and divided them according to shade, color scheme, texture and so on, cut them into small squares and triangles and joined them to make all kinds of ribbon tapes. On the base cloth, which has to blend in with those colors and bring them together, I also overlapped many colors layer upon layer for a vivid effect, giving balance to the finished work. Bits of white in the piecework provide accent color, setting off all the other shades. The design is a traditional frame quilt, and the quilting pattern makes the most of simple straight lines.

When you make ribbon tape, choose various materials from those you have collected over the years; select a complementary color that you especially like for the base cloth, or use white, which goes well with any color; then arrange the ribbon on top, and you will see you have made a lovely quilt with clean lines.

LEFT: Quilts from my "Color" series (TOP TO BOTTOM): "Color II," "Color III," "Color IV" and "Color 1." FAR RIGHT: "Color II," detail. ABOVE: Sappanwood. RIGHT: Teak leaves.

COLOR II

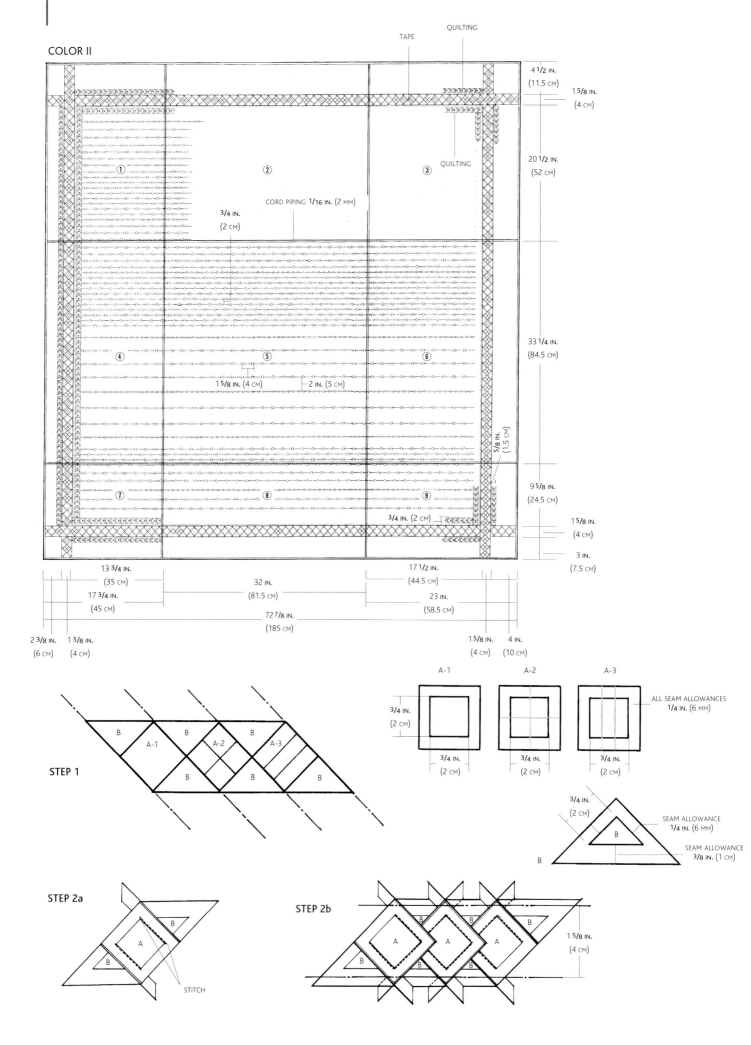

TAPE QUILTING

4 1/2 IN. (11.5 CM)

1 5/8 IN. (4 CM)

QUILTING

20 1/2 IN. (52 CM)

CORD PIPING 1/16 IN. (2 MM)

3/4 IN. (2 CM)

33 1/4 IN. (84.5 CM)

1 5/8 IN. (4 CM) 2 IN. (5 CM)

5/8 IN. (1.5 CM)

9 5/8 IN. (24.5 CM)

3/4 IN. (2 CM)

1 5/8 IN. (4 CM)

3 IN. (7.5 CM)

13 3/4 IN. (35 CM)

17 1/2 IN. (44.5 CM)

32 IN. (81.5 CM)

17 3/4 IN. (45 CM)

23 IN. (58.5 CM)

72 7/8 IN. (185 CM)

2 3/8 IN. (6 CM) 1 5/8 IN. (4 CM)

1 5/8 IN. (4 CM) 4 IN. (10 CM)

STEP 1

B A-1 B B

B A-2 B

A-3

B B B

A-1 A-2 A-3

3/4 IN. (2 CM)

3/4 IN. (2 CM)

ALL SEAM ALLOWANCES 1/4 IN. (6 MM)

3/4 IN. (2 CM)

B SEAM ALLOWANCE 1/4 IN. (6 MM)

B SEAM ALLOWANCE 3/8 IN. (1 CM)

STEP 2a

B

A

B

STITCH

STEP 2b

B B B

A A A

B B B

1 5/8 IN. (4 CM)

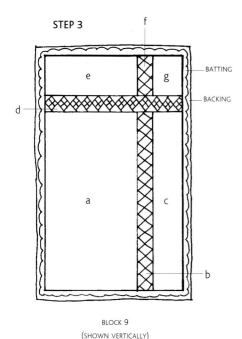

BATTING

BACKING

BLOCK 9
(SHOWN VERTICALLY)

MATERIALS: Silk, cotton and wool, dyed with natural dyes

TOP CLOTH: Silk dyed with natural dyes 1 yd. 7 ¼ in. x 7 yds. 23 ⅝ in. (110 cm x 7 m; this amount includes bias tape cord piping and bias tape)

BATTING: Cotton

BACKING: Cotton dyed with natural dyes 1 yd. 11 ¼ in. x 6 yds. ½ in. (120 cm x 5.5 m)

ACCENT COLOR: Silk, cotton and wool dyed with natural dyes (small amounts)

TECHNIQUES: Piecing, free-motion machine quilting

COMPLETED SIZE: 72 ⅞ x 74 in. (185 x 188 cm)

STEP 1: Start with the ribbon tape for the edge (use whatever colors you like as the accent color). Make the following 4 cardboard templates.

A1 1 patch ¾ in. (2 cm) square

A2 Join 4 patches ⅜ in. (1 cm) square

A3 Join 3 oblong patches

B Isosceles triangle half the size of A

STEP 2a: Piece B-A-B together. Stitch along the stitch lines as shown, and fold the seam allowances down towards B. Use all the A and B pieces to make the B-A-B blocks.

STEP 2b: To join the B-A-B blocks, place the B of the next block alongside the A of the first block and stitch along the stitch line. Tie off the thread. Stitch the A of the next block to the B of the first block, along the stitch line. Tie off the thread. Repeat. Mark the fabric so the finished product will be 1 ⅝ in. (4 cm) wide.

STEP 3: Divide the quilt top into 9 sections, and complete 1 section at a time. For instance, to create block (9) from the overall pattern, cut out (a) and (c) and join them with ribbon (b). Then cut out (e) and (g) and join them with ribbon (f). Join these 2 blocks with ribbon (d). Layer this with the batting and backing; quilt. Finish the remaining blocks in the same way, then stitch together the 3 main sections (blocks 1, 2 and 3; 4, 5 and 6; and 7, 8 and 9). Join the 3 sections (see p. 109, Steps 4a through 5).

COLOR III

MATERIALS: Silk, cotton and wool, dyed with natural dyes

TOP CLOTH: Silk dyed with natural dyes, 1 yd. 7 ¼ in. x 7 yds. 23 ⅝in. (110 cm x 7 m; this amount includes bias tape cord piping and bias tape)

BATTING: Cotton

BACKING: Cotton dyed with natural dyes 1 yd. 11 ¼ in. x 6 yds. ½ in. (120 cm x 5.5 m)

ACCENT COLOR: Small amount

TECHNIQUE: Piecing, free-motion machine quilting

SIZE: 72 ⅞ in. (185 cm) square

STEP 1: Start with a ribbon tape ⅝ in. (1.5 cm) wide. Using Seminole patchwork methods (**INSTRUCTIONS ON SEMINOLE PATCHWORK CAN BE FOUND ON P. 125**), piece together the top fabric and contrasting colors as shown, and cut in a width of 1 in. (2.5 cm). Arrange the cut pieces as shown and stitch together in a ribbon.

STEP 2: There are 7 sections; complete 1 at a time. Join as on p. 109.

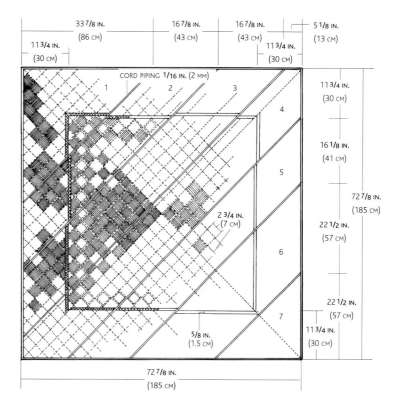

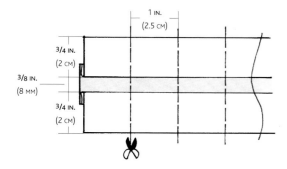

STEP 1

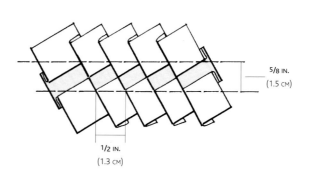

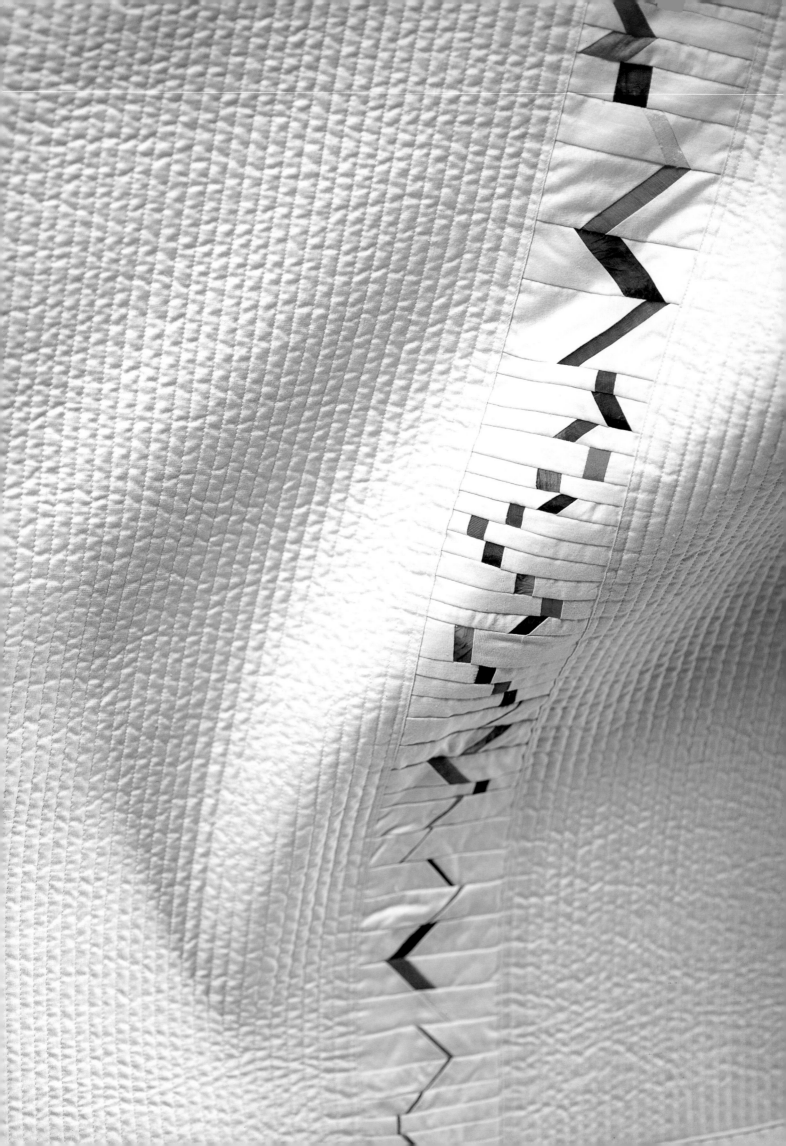

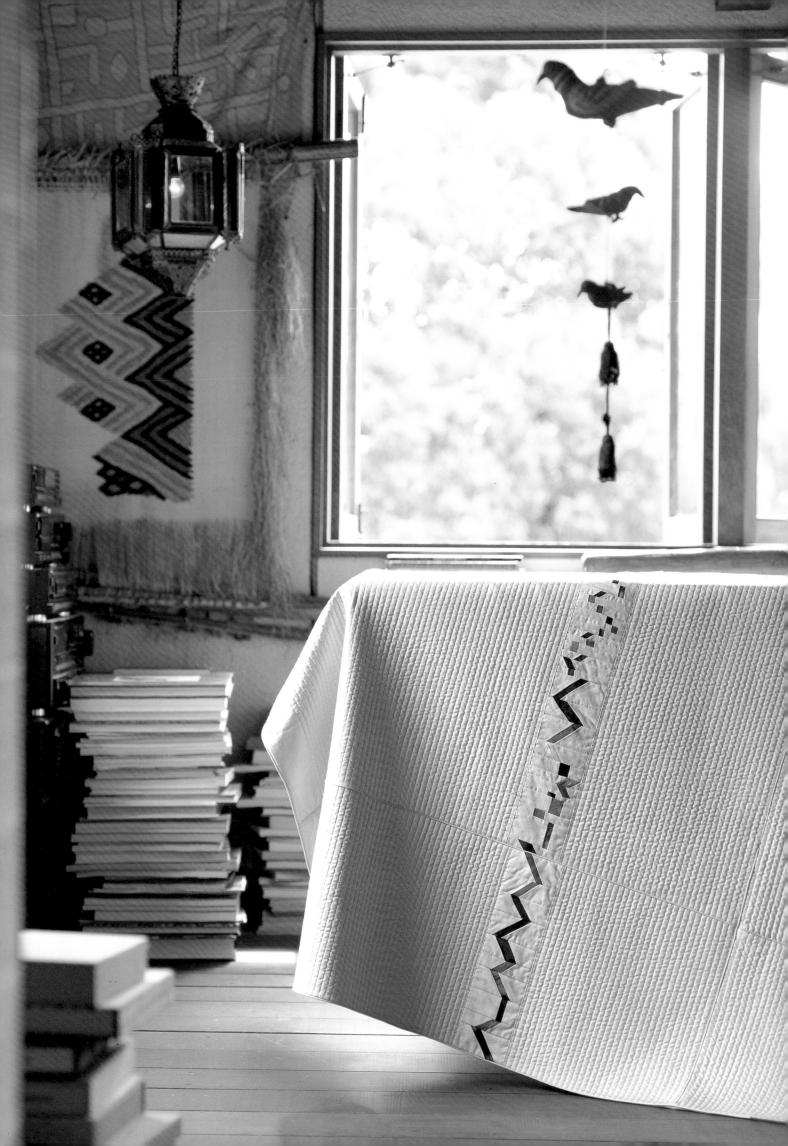

PAGE 106–7: "Dew II."

This is a quiet white quilt with rhythmical touches of color. This work is part of a series (see also "Dew I," pages 18–19), the idea for which came to me once when I was traveling through a tropical jungle: the scenery made an indelible impression on me and gradually was expressed in this form.

Using bamboo-dyed white as a base for coordinating the other shades achieved with natural dyes has led me to several new designs that are essentially collaborations between white and color.

Combining cloth ribbons with bold prints is a good idea. Why not try experimenting with it yourself? Paying attention to the balance between wide and narrow and dark and light pieces can help you find a pleasing rhythm of your own. Make as many ribbon tapes as possible and then choose among them.

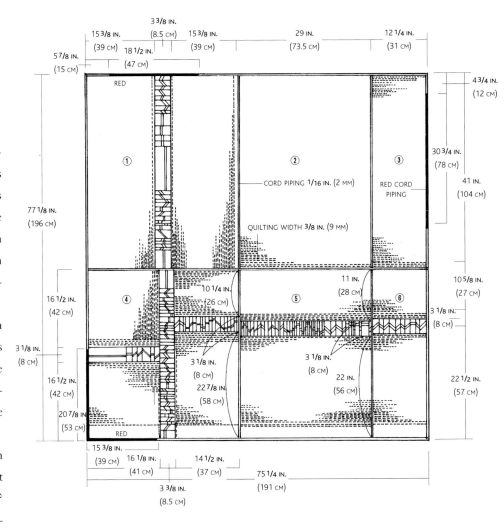

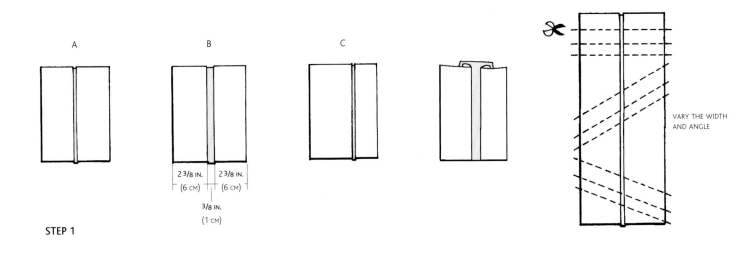

STEP 1

VARY THE WIDTH AND ANGLE

D E

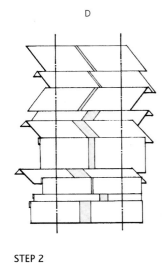

SECTION 6

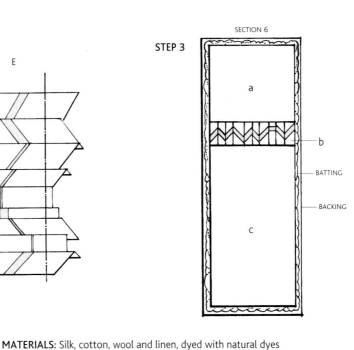

a

b

BATTING

BACKING

c

STEP 2

ATTACH THE BIAS TAPE

CORD PIPING

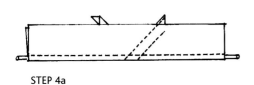

MATERIALS: Silk, cotton, wool and linen, dyed with natural dyes
TOP CLOTH: Bamboo-dyed silk, 1 yd. 7 ¼ in. x 8 yds. 27 in. (110 cm x 8 m; this amount includes bias tape cord piping and bias tape)
BATTING: Cotton
BACKING: Bamboo-dyed silk / cotton blend, 1 yd. 11 ¼ in. x 6 yds. ½ in. (120 cm x 5.5 m)
ACCENT COLOR: Silk, cotton, linen and wool dyed with natural dyes (small amounts)
TECHNIQUE: Piecing, machine quilting
COMPLETED SIZE: 75 ¼ x 77 ⅛ in. (191 x 196 cm)

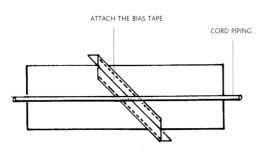

STEP 4a

STEP 1: Begin with cloth ribbon tape of whatever colors you like. Between two 2 ⅜-in. (6-cm)–wide pieces of top cloth, insert a piece of a matching color in widths of ¹⁄₁₆ in., ⅜ in. and ⅝ in. (2 mm, 1 cm and 1.5 cm), and sew together to make long ribbons of types A, B and C. Cut in widths of ⅜ in., ¾ in., 1 ¼ in. and 2 in. (1, 2, 3 and 5 cm; it's also a good idea to vary the angles for visual interest).

STEP 2: Lay out the cut pieces in various ways to make ribbons like D and E (3 ⅛ in. and 3 ⅜ in. wide / 8 cm and 8.5 cm).

STEP 3: Divide the quilt top into six sections and complete one section at a time. Cut out (a) and (c) and stitch to ribbon tape (b). Layer this with the batting and backing and quilt to complete section 6. Complete the other five sections.

STEP 4a: Piece the blocks together with bias tape cord piping 1 ⅝ in. (4 cm) wide, as in the diagram. When the bias tape is short or you want to change colors, join two tapes at 45° angles, open the seam allowance slightly and stitch on both sides.

STEP 4b: Make two halves from blocks 1, 2 and 3 and blocks 4, 5 and 6; join as in the diagram.

STEP 5: Sew bias tape cord piping and bias tape around the edge, fold over the bias tape and blindstitch in back.

CORD PIPING

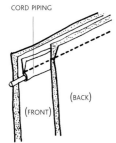

(BACK)

(FRONT)

(BACK)

BIAS TAPE
1 IN. (2.5 CM) CORD PIPING

(FRONT)

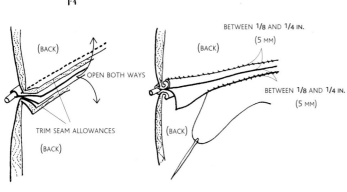

(BACK)

OPEN BOTH WAYS

TRIM SEAM ALLOWANCES

(BACK)

(BACK)

BETWEEN ⅛ AND ¼ IN.
(5 MM)

(BACK)

BETWEEN ⅛ AND ¼ IN.
(5 MM)

(BACK)

STEP 4b

3/8 IN.
(1 CM)

1/8 IN.
(3 MM)

(BACK)

STEP 5

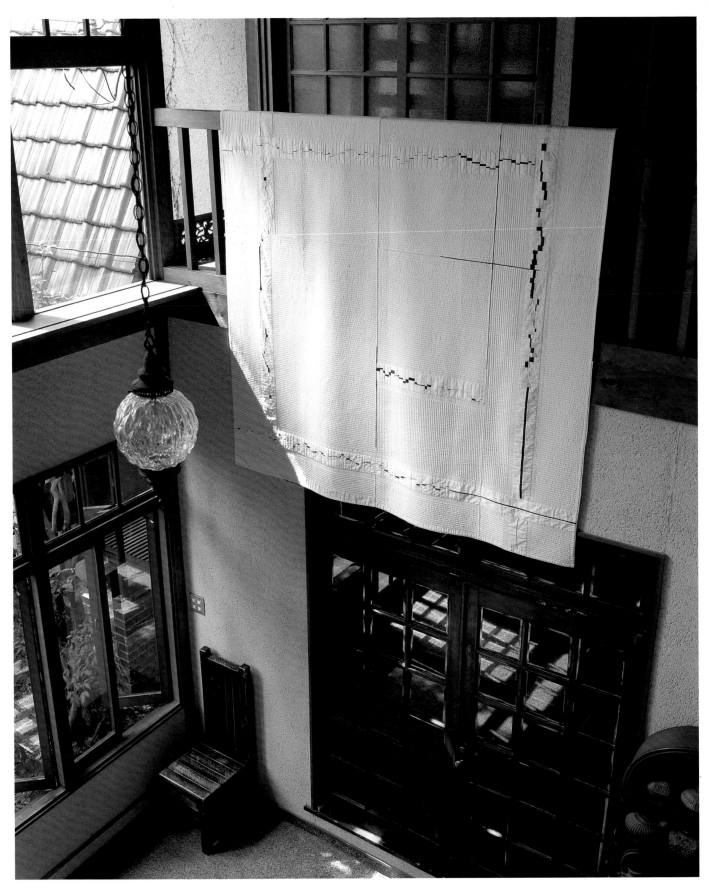

LEFT: "Sound," detail. ABOVE: "Sound" hanging in the entryway of my house in Kyoto.

This quilt is based on a simple tricolor combination of gold, bamboo-dyed white, and black, with white as the keynote. By layering natural dyes of various colors and in various ways, I obtained four separate shades of black for a deeper effect. I experimented over and over, trying to find the exact amounts of black and gold to best set off the quilted white, and the amount of white that would best bring out the effects of the gold and black.

I divided the quilt into six sections and quilted them separately, then assembled the finished blocks vertically and horizontally to make the quilt. In so doing I discovered that a splash of color in the cord piping at the joints added to the beauty of the overall construction.

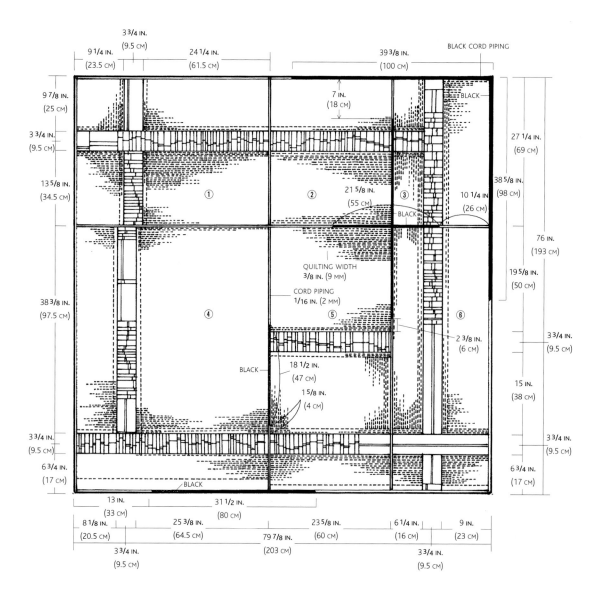

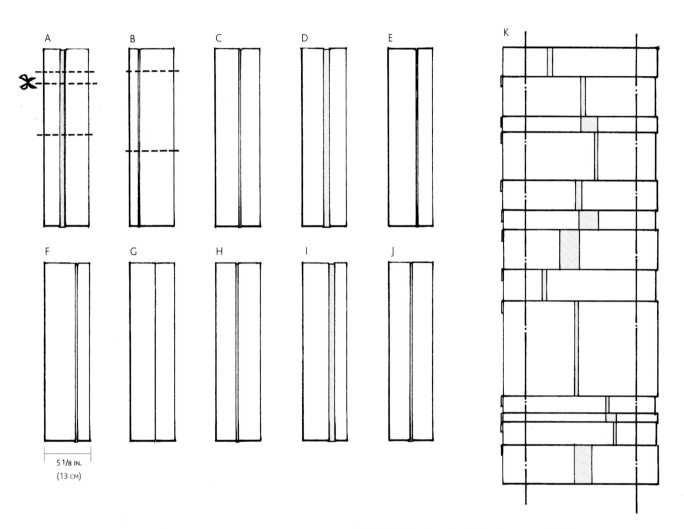

MATERIALS: Bamboo-dyed silk and cotton, gold foil

TOP CLOTH: Bamboo-dyed silk / cotton blend, 1 yd. 11 ¼ in. x 8 yds. 27 in. (120 cm x 8 m; this amount includes bias tape cord piping and bias tape)

BATTING: Cotton

BACKING: Bamboo-dyed silk / cotton blend, 1 yd. 11 ¼ in. x 6 yds. (120 cm x 5.5 m)

ACCENT COLORS: Silk dyed with natural dyes and silk coated with gold leaf (small amounts)

TECHNIQUE: Piecing, machine quilting

COMPLETED SIZE: 76 x 80 in. (193 x 203 cm)

STEP 1: Begin with cloth ribbon tape in your choice of colors. Insert strips of black and gold foil cloth in widths of ¹⁄₁₆ in., ⅜ in., ⅝ in. and ¾ in. (2 mm, 1 cm, 1.5 cm and 2 cm) to make 5 ⅛-in. (13-cm)–wide blocks A through J. For visual interest, vary the position and width of the contrasting colors as shown and cut. Assemble the cut pieces to make a long ribbon 3 ¾ in. (9.5 cm) wide.

STEP 2: Divide the quilt top into 6 sections and complete 1 at a time (for instructions, see p. 109, Steps 3–5).

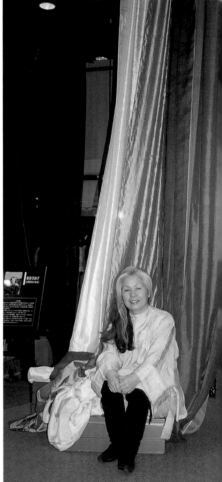

BEGINNINGS

This is the first quilt of mine ever shown in public. I made it back in 1979 and submitted it to the Ontario Crafts Council's competition and was amazed when it was awarded the Provincial Prize. I know that some of the projects I have shown in this book are difficult, and I thought that having a chance to go back and see the beginning of the journey might be an encouragement to quilters who are starting out.

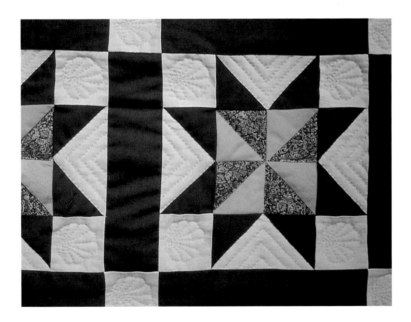

ABOVE: "Star Quilt," the first quilt of mine ever exhibited in public, in the Ontario Crafts Council's competition in 1979 (see also page 27). RIGHT (TOP TO BOTTOM): Optical Quilt: "Shimmering Waves" on display at Yamaso Art Gallery, Kyoto, 2000; at an exhibit at Tamagawa Takashimaya, Tokyo, 1996; randomly pieced bamboo-dyed silk organdy; floor-to-ceiling lengths of my bamboo-dyed silk shibori in the lobby of the 2002 International Quilt Festival in Nagoya.

ADDITIONAL DESIGNS, PATTERNS AND INSTRUCTIONS

SMALL MODERN
AMISH QUILTS
PAGES 34–37

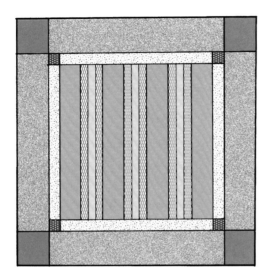

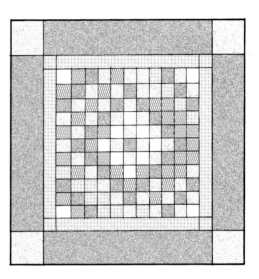

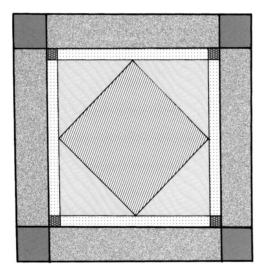

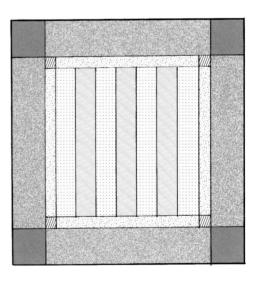

TOP LEFT: The completed quilt is
shown on page 24. TOP RIGHT:
Shown on page 35, top. LOWER
RIGHT: Shown on page 35, bottom.

KEY

	Silk (black lacquered)		Wisteria cloth
	Silk (brown lacquered)		*Tapa* (Africa, red-brown)
	Tapa (Kalimantan [Indonesia], yellow-brown)		*Ulap doyo* (East Kalimantan)
	Abaca (the Philippines)		Cotton
	Shifu (woven paper cloth)		Linen
	Shina cloth (from the fiber of Japanese *shina* trees)		Silk kimono fabric

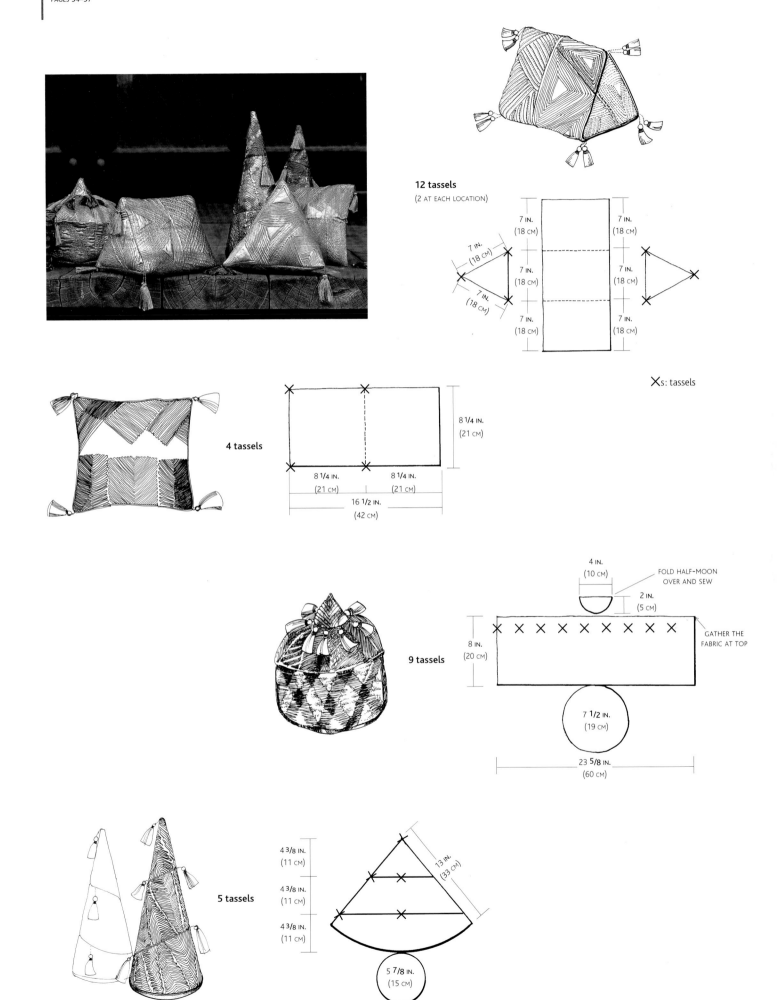

12 tassels

(2 AT EACH LOCATION)

7 IN.
(18 CM)

7 IN.
(18 CM)

7 IN.
(18 CM)

7 IN.
(18 CM)

7 IN.
(18 CM)

7 IN.
(18 CM)

7 IN.
(18 CM)

7 IN.
(18 CM)

✕s: tassels

4 tassels

8 1/4 IN.
(21 CM)

8 1/4 IN.
(21 CM)

8 1/4 IN.
(21 CM)

16 1/2 IN.
(42 CM)

4 IN.
(10 CM)

FOLD HALF-MOON
OVER AND SEW

2 IN.
(5 CM)

9 tassels

8 IN.
(20 CM)

GATHER THE
FABRIC AT TOP

7 1/2 IN.
(19 CM)

23 5/8 IN.
(60 CM)

5 tassels

4 3/8 IN.
(11 CM)

4 3/8 IN.
(11 CM)

4 3/8 IN.
(11 CM)

13 IN.
(33 CM)

5 7/8 IN.
(15 CM)

117

Motifs from African raffia textiles, also known as "Kuba velvet," provided a starting point for my imagination. No two pieces of woven raffia cloth are ever the same. The natural shapes and patterns of thought that emerge in handcrafted Kuba velvet became an instrument for my own creativity.

I toned down the metallic sheen of silver fabric, deepening the silver, and placed jet-black velvet in the center of the spiral, accenting it with shiny gold. The base cloth is sheer black nylon. The motif is simple and strong, while the textiles are contemporary.

The primitive world and our own seem poles apart, but by fusing the two we can regain the human birthright of purity, magnanimity, and freedom of spirit that the modern world has given up in exchange for scientific progress.

Kuba velvet. Handwoven cloth from fibers of the raffia palm, embroidered with raffia thread. Kuba people, Republic of Congo. Author's collection.

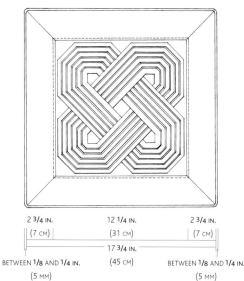

2 3/4 IN. (7 CM) 12 1/4 IN. (31 CM) 2 3/4 IN. (7 CM)

17 3/4 IN. (45 CM)

BETWEEN 1/8 AND 1/4 IN. (5 MM) BETWEEN 1/8 AND 1/4 IN. (5 MM)

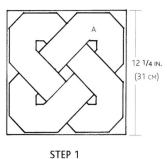

12 1/4 IN. (31 CM)

STEP 1

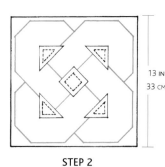

13 IN 33 CM

STEP 2

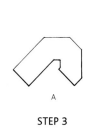

A

STEP 3

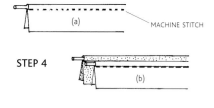

(a) MACHINE STITCH

STEP 4

(b)

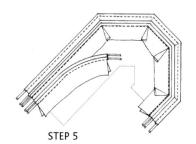

STEP 5

MATERIALS: Nylon, aluminum-coated nylon, aluminum-coated polyester
BASE CLOTH: Nylon 1 yd. 7 1/4 in. x 20 in. (110 x 50 cm)
CORD PIPING: Aluminum-coated nylon, aluminum-coated polyester 1 yd. 7 1/4 in. x 11 3/4 in. (110 x 30 cm)
BACKING: Nylon 20 in. (50 cm) square
EDGING: Nylon bias tape cord piping 1 5/8 in. x 1 yd. 6 3/4 in. (4 x 200 cm)
STUFFING: Polyester or cotton
TECHNIQUE: Piecing of cord piping, appliqué
COMPLETED SIZE: 18 1/8 in. (46 cm) square

STEP 1: Copy the center design on a copy machine, enlarging it to 31 cm square.

STEP 2: Transfer the design to the quilt top with chalk paper. Cut accent cloths into 4 triangles and 1 square as shown and baste to the quilt top. Leave seam allowances of 3/8 in. (1 cm).

STEP 3: Make a template of pattern A from thin cardboard.

STEP 4: Cut cloth in ribbons 2 3/8 in. (6 cm) wide. Fold in half and insert cord in the center. For (a), make just 1 of these. For (b), make 2 and sew together.

STEP 5: Connect 11 lengths of cord piping as shown, to make 4 shapes of template A. Place 1 length of single cord piping along the outer edge of the design, and 5 lengths of double cord piping beneath: first lay down the outer layer, leaving a 3/8-in. (1-cm) seam allowance. Then lay down the second layer and secure with pins or baste, then stitch. Repeat for remaining layers.

STEP 6: Lay down the 4 shapes of template A on the base cloth as in the overall pattern (above left). Hide each seam allowance under the next shape, then sew along the outermost lines. (Align the top of the second unit to the stitch line of the first, and stitch on the stitch line of the second unit.) Add a frame 2 3/4 in. (7 cm) wide, and stitch (for instructions, see p. 49, Step 5b). Lay entire design on quilt top and sew.

STEP 7: Sew the cushion and finish with bias tape cord piping as shown in the diagram on p. 52.

Insert round cord into black fabrics of contrasting texture as for a Spiral Block, in a Log Cabin pattern. You can vary the design by altering the number of different materials you use, from one to four. Wind braiding around the perimeter and undo at the tip to form a tassel.

The bag may be worn as an accessory hung from the shoulder or waist. Each work is an intricate but simple design that provides a welcome accent as room decoration; hung on pillars or chairs, they are very striking. Choose a color to match a favorite outfit, or add shiny metallic fabric of gold or silver to make a bright and attractive accessory.

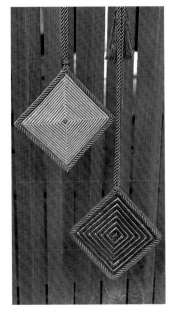

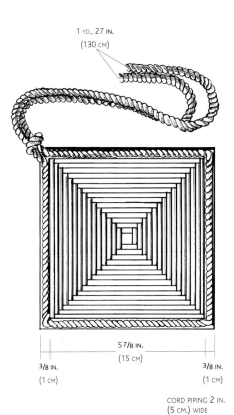

1 YD., 27 IN.
(130 CM)

5 7/8 IN.
(15 CM)

3/8 IN.
(1 CM)

3/8 IN.
(1 CM)

CORD PIPING 2 IN.
(5 CM.) WIDE

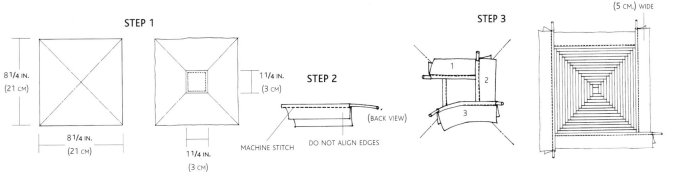

STEP 1

8 1/4 IN.
(21 CM)

8 1/4 IN.
(21 CM)

1 1/4 IN.
(3 CM)

1 1/4 IN.
(3 CM)

STEP 2

(BACK VIEW)

MACHINE STITCH

DO NOT ALIGN EDGES

STEP 3

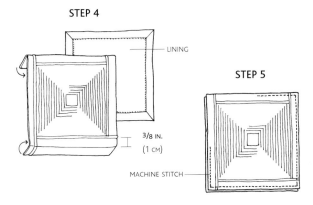

STEP 4

LINING

3/8 IN.
(1 CM)

MACHINE STITCH

STEP 5

MACHINE STITCH

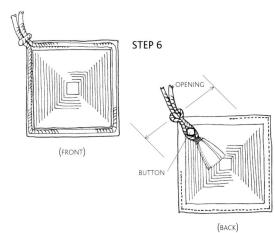

STEP 6

(FRONT)

OPENING

BUTTON

(BACK)

MATERIALS: Cotton, nylon, polyester, rayon, titanic oxide–coated nylon
BASE CLOTH: 2 thin cotton cloths, each 8 1/4 in. (21 cm) square
LINING: 2 polyester cloths, each 7 7/8 in. (20 cm) square
CORD PIPING: 1 yd. 7 1/4 in. x 20 in. (110 x 50 cm) square
STRAP: Polyester braid 2 yds. 18 1/2 in. (230 cm)
TECHNIQUE: Piecing of cord piping
SIZE: 6 5/8 in. (17 cm) square

STEP 1: Prepare a 8 1/4-in. (21-cm)–square base cloth and baste marking lines along the diagonals. Place a piece of metallic cloth 1/4 in. (3 cm) square in the center and baste.

STEP 2: Insert narrow cord into 1 1/4-in. (3-cm)–wide tape cloth and machine stitch in place. Prepare a 2-in. (5-cm)–wide cloth for the outer circumference of the block (in order to fold it in).

STEP 3: As in the diagram, sew (1) cord piping to the central metallic cloth, leave a seam allowance and cut. Sew (2) and (3) as for a Log Cabin block, using 2-in. (5-cm)–wide cord piping around the outer edge.

STEP 4: Make 2 blocks, leaving a 3/8-in. (1-cm) margin for each, and fold towards the back. Prepare the lining and attach it with a blindstitch as shown.

STEP 5: Layer the two cloths and machine stitch along the dotted line, leaving an opening as shown.

STEP 6: Sew braiding around the edge in front by hand. Leave a length of 1 yd. 27 in. (130 cm) for the strap. In back, add button and make a decorative loop, as in the diagram.

PATTERN A

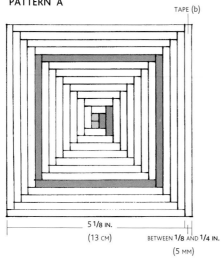

TAPE (b)

5 1/8 IN.
(13 CM)

BETWEEN 1/8 AND 1/4 IN.
(5 MM)

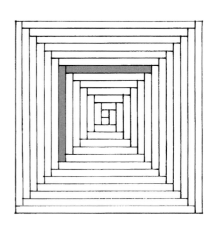

PATTERN B (JOIN 4 SMALL TRIANGLES IN A SQUARE SHAPE TO MAKE THE CENTER)

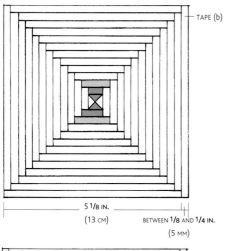
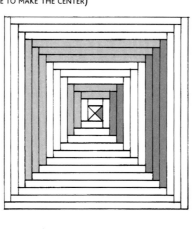
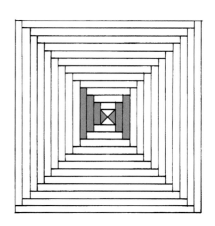

TAPE (b)

5 1/8 IN.
(13 CM)

BETWEEN 1/8 AND 1/4 IN.
(5 MM)

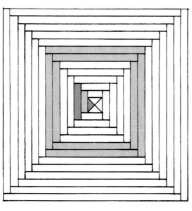
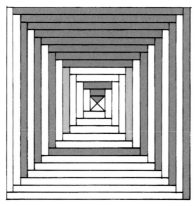
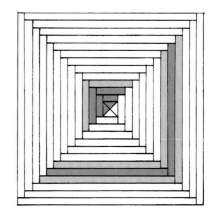

EGG HANGER (1 CORD)

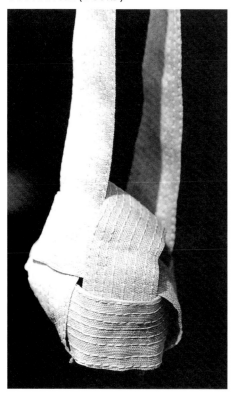

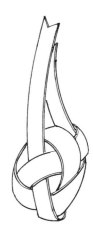

BASKET (4 CORDS)

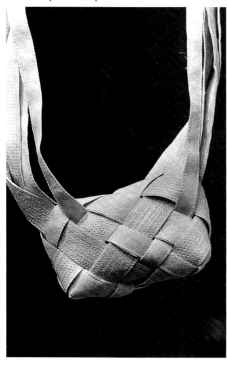

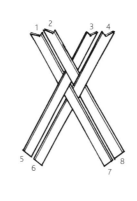

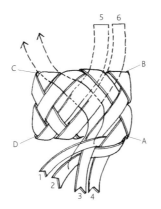

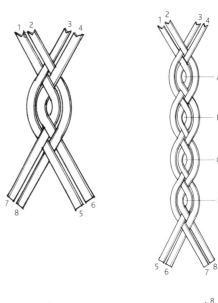

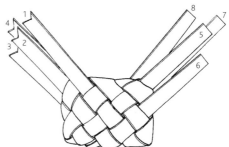

7 AND 8 ARE BEHIND 5 AND
6, AND CANNOT BE SEEN.

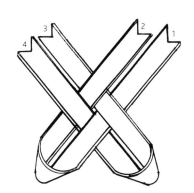

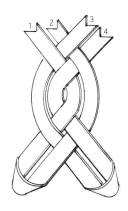

TRIANGLE (2 CORDS)

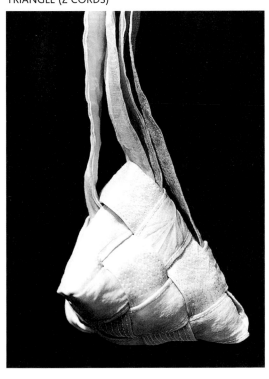

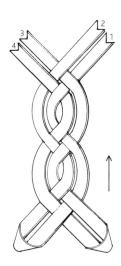

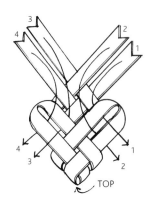

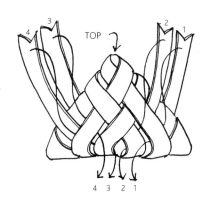

This is a cloth version of a table mat that I first made by braiding cords of beautiful natural colors, obtained by drying the outer layers of banana stalks. I tried to express the same idea in a different form here by braiding together three kinds of silk of slightly different textures. The shading achieved by the woven texture and the natural quality of the uneven fringe go very well with ceramics that have a rough or unfinished quality.

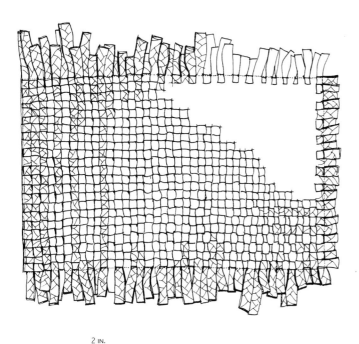

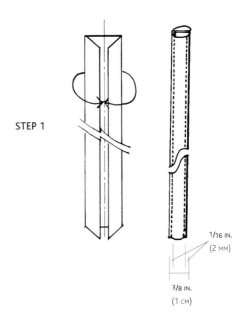

STEP 1

1/16 IN.
(2 MM)

3/8 IN.
(1 CM)

STEP 2

STITCH AND CUT ENDS

1/2 IN.
(1.2 CM)

STEP 3

2 IN.
(5 CM)

11 IN.
(28 CM)

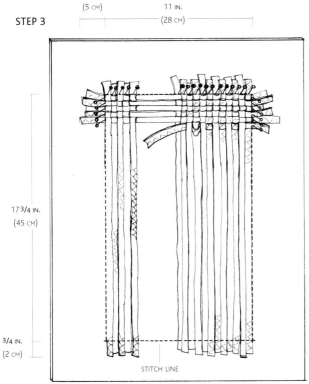

17 3/4 IN.
(45 CM)

3/4 IN.
(2 CM)

STITCH LINE

THICK CARDBOARD
17 3/4 IN. x 24 IN. (45 x 60 CM)

MATERIALS: Bamboo-dyed silk organdy 1 yd. 7 ¼ in. x 6 yds. ½ in. (110 cm x 5.5 m)

TECHNIQUE: Braiding

COMPLETED SIZE: About 19 x 15 in. (48 x 38 cm) including fringe

STEP 1: As in the diagram, cut the material into ribbons 1 ⅝ in. (4 cm) wide (vertical tapes should be 31 ½ in. /80 cm long, and horizontal tapes 24 ⅜ in. /62 cm long). Fold the tapes in fourths and add 2 stitch lines. Make 69 vertical and 129 horizontal tapes.

STEP 2: Braid all the tapes (braiding 3 of each kind of fabric together), until you have 23 vertical and 43 horizontal tapes. Stitch along the ends, and cut the ends straight.

STEP 3: Pin one end of all the vertical ribbons to a piece of thick cardboard. Add the horizontal ribbons, and weave together tightly. Stitch all four sides when you reach the desired size.

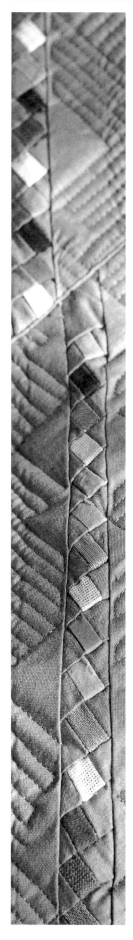

SEMINOLE PATCHWORK

The Seminole Indians of Florida have a proud history. The word "Seminole" is of Creek origin and has many meanings, among them "wild," "rebel" and "runaway." Seminole history has been one of successive wars, from the early days of English and Spanish colonization to the costly battle of resistance led by their chief Osceola in the 1830s. The Seminoles incorporated Spanish dress styles and Scottish plaids in a unique style of patchwork all their own.

Take bright calico and gingham of solid, contrasting colors, cut them in strips and patch together, then cut and paste them again to make ribbons of various designs for decorating garments. These are used with braided lace. A Seminole woman's traditional outfit was typically a floor-length patchwork dress, shoulder cape, strand upon strand of colorful beads and a hairnet. Men often wore patchwork shirts.

All the patchwork is machine-sewn. This technique is difficult to do with soft fabrics, and may work better with stiffer cloth. Allow a ¼-in. (6-mm) seam allowance.

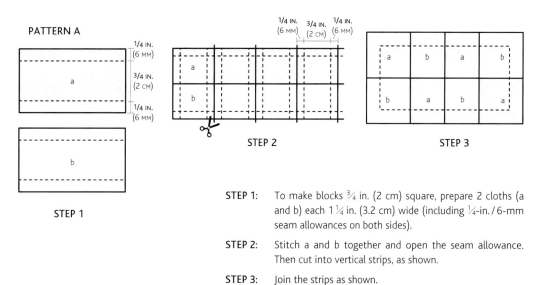

PATTERN A

STEP 1: To make blocks ¾ in. (2 cm) square, prepare 2 cloths (a and b) each 1¼ in. (3.2 cm) wide (including ¼-in./6-mm seam allowances on both sides).

STEP 2: Stitch a and b together and open the seam allowance. Then cut into vertical strips, as shown.

STEP 3: Join the strips as shown.

PATTERN B

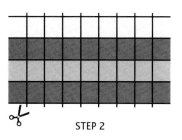

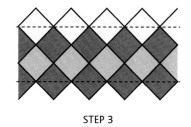

STEP 1: Prepare 4 cloths and join.

STEP 2: Cut into vertical strips.

STEP 3: Join the strips on the diagonal, as shown.

ACKNOWLEDGMENTS

In the course of making this book, I have become indebted to a great many people, and I would like to take this opportunity to express my deepest appreciation.

Mr. Jun'ichi Arai has always provided me with the courage and the energy to grapple with things in creative ways; now he has also kindly written the preface to this book. Mr. Toshihiro Imai has been a tremendous help in organizing my exhibits for ten years now; from him I have learned how to live life more deeply, and his way of seeing has had a great influence on my quilting creations.

Taizen Tsujimura, head priest of the Gangoji temple in Nara—a UNESCO World Heritage Site since 1998—graciously allowed me to photograph my quilts in the temple and to borrow important materials.

Also, my sincere thanks go to all of the following: Shigeki Kawakami of the Kyoto National Museum; Nagai Textiles; Yasuhiro Takahashi; Hikaru Shimomura; the Gangoji temple; Naomi Ueda of the Gangoji Institute for Research into Cultural Property; the Kokiji temple; the Esprit Quilt Collection of Doug Tompkins of San Francisco; the Textile Museum of Canada; photographers Kazuo Minato, Michiko Matsumoto, Mizuho Kuwata and Hiroya Kaji; students of the Yoshiko Jinzenji Quilting School, and the staff of Grass House Studio in Bali.

I am very grateful to all those who helped craft this book: at Kodansha International these were my editors Elizabeth Floyd, Shigeyoshi Suzuki and Machiko Moriyasu, and book designer Kazuhiko Miki. Yoshiko Iwamoto Wada helped shape the text at the early stages. Special thanks must also go to Juliet Winters Carpenter for her fine translation.

Finally I would like to say thank you to my family.

ALL SKETCHES AND DIAGRAMS BY KO JINZENJI

PHOTO CREDITS

KAZUO MINATO
4–5; 9; 12–13; 16–17; 20–21; 24; 25; 28; 29; 34; 35; 38; 39; 42; 43; 46; 47; 50; 51; 54; 55; 56 (TOP LEFT); 58; 59; 62 (ALL BUT FAR LEFT); 63; 82 (LEFT); 83; 86 (LEFT); 91 (BOTH); 96; 97; 99; 102; 103 (FAR RIGHT); 106; 107; 110; 111; 117; 118 (BOTH); 119; 125

YOSHIKO JINZENJI
11; 14 (FAR LEFT); 23 (THREE ON FAR RIGHT); 62 (FAR LEFT); 66 (ALL BUT TOP MIDDLE AND CENTER OF PAGE [POR-TRAIT]); 67 (BOTH); 68; 70; 71 (BOTH); 72 (ALL); 74 (LEFT); 78 (LEFT); 79; 90 (ALL); 92; 103 (TWO IN CENTER); 114 (ALL); 121 (BOTH); 122; 123

MICHIKO MATSUMOTO
15; 66 (TOP MIDDLE; CENTER [PORTRAIT]); 75; 94 (LEFT); 95; 98

MIZUHO KUWATA
10; BOOK JACKET

HIROYA KAJI
18–19; 87 (COURTESY OF BUNKA SHUPPANKYOKU)

RIO HELMI
22

RACHAEL ASHE
27

KO JINZENJI
73

abaca: Fiber obtained from banana leafstalks. Also known as Manila hemp.

batik: Indonesian wax-resist dyeing process in which wax is stamped or drawn on the areas of cloth that are to resist the penetration of dye.

bias tape: Long, narrow piece of fabric that stretches because it is cut on the diagonal.

blindstitch: Type of stitch used for bindings or to secure fabric to the back of a quilt. The needle is brought up from beneath, through the shape to be attached and near its edge, then brought down again through the background fabric, just across from where the stitch was started. Stitches should be kept very close together.

Crazy Quilt: Quilt made of patches cut from many fabrics in irregular shapes and various sizes, often decorated with embroidery. In the late nineteenth century, usually made of rich fabrics such as silk, satin, velvet and brocade.

cupra (cupramonium rayon): New fiber made from cellulose. Unlike other cellulose fibers, it has a drape and sheen almost exactly like silk.

frame: Fabric strips placed around quilt blocks to finish them. Also known as sashing.

frame quilt: Traditional quilt pattern of concentric frames, often seen in early works from the quilt history of North America: pieces of fabric are pieced in the center and a frame is made around them. Piecework is done around the frame, and the process repeated.

free-motion machine quilting: Method of quilting done on a sewing machine, in which the feed dogs are lowered or covered so that the quilter can control the movement of the fabric under the needle and create freeform designs.

funzoe: Joined priest's surplice (*kesa*) that features stitching over the entire surface. Made by layering and quilting the fabric. *See also* kesa

interfacing: Thin but firm fabric that is used to stabilize fabrics that are being stitched together, particularly if one of the fabrics is fragile.

Irish Chain: Traditional quilt pattern consisting of parallel chains of blocks. There are many variations on this pattern.

kembangan: Type of *selendang* (a traditional Indonesian shawl) that features a large colored rectangle on a contrasting background; the pattern is obtained by shibori shaped-resist using natural dyes.

kesa: Priest's joined surplice, worn hanging from the shoulder. *See also* funzoe

ketupat: Variously shaped objects made of braided fresh young coconut fronds. They have many uses, one of which is as packets for steaming rice on celebratory occasions.

Kuba velvet: Handcrafted cloth made from fibers of the raffia palm and embroidered with raffia thread. Also known as raffia.

lime: White powder consisting mainly of calcium oxide. In indigo dyeing, it is used to separate the water and the indigo.

Log Cabin: Traditional quilt pattern in which small strips of fabric are arranged so that they spiral outward from the center in a block shape.

lye: Alkaline solution obtained by mixing water with the ash that results from burning straw or various kinds of woods. This solution is used, when dyeing silk, as a mordant. It is also essential to the process of indigo dyeing.

machine quilting: *See* free-motion machine quilting

mandala: Symbolic geometric or pictorial representation of the universe, sometimes used in Buddhist or Hindu meditation.

melt-off: Process in which aluminum used to coat polyester threads is treated chemically so that it loses its luster, creating patterns on the cloth. Developed by Jun'ichi Arai in 1958 and first used in industrial applications in 1964.

nesting Prairie Points: Method of finishing in which small folded squares are set one into the next for an interlocking sawtooth border.

Nine Patch: Block design featuring three rows of three squares in a checkerboard pattern.

patola: Tradition developed in Gujarat, India of rare double-ikat weaving on silk. Both the warp and weft threads are separately bound and dyed so that they interlock in the woven cloth in a decorative pattern.

pintuck: Technique in which small folds are pinched into fabric and stitching is done along and close to the folds.

Prairie Points: *See* nesting Prairie Points

raffia: *See* Kuba velvet

rontal: Leaves of the rontal tree (a type of palm), dried and used as writing paper, for plaited mats or as ornaments

sarong: Indonesian garment made from a rectangular piece of cotton or silk formed into a tube and stitched.

sarung tapis: Indonesian ceremonial sarong that features embroidery with gold thread on vertically striped cotton. *See also* sarong

sashiko: Form of quilting developed in Japan, particularly the cold northern regions of the country, in which indigo-dyed fabric (of one layer, or several cloths layered together) are quilted in decorative patterns using a simple running stitch of white cotton thread.

sashing: *See* frame

seam allowance: Width of fabric from the edge to the stitching.

selendang: Traditional shawl from Indonesia draped from the shoulder and usually worn by women. *See also* kembangan

shibori: Shaped-resist dyeing. Process in which fabric is tied, clamped or otherwise held back during dyeing, to resist the penetration of dye.

shifu: Woven paper cloth, the threads for which are made of twisted strips of paper. Paper yarns are sometimes used for both warp and weft, and in other cases silk or cotton is used for the weft.

shina cloth: Fabric made from the fiber of the *shina* (Japanese linden) tree. The texture is rough and stiff, and the color is yellowish brown. Its history in Japan spans 1,300 years—much longer than cotton or silk.

soga: Indonesian natural dye made from wood and bark. The three main ingredients of the dye are *tinggi* shrub bark (red), *jambal* tree bark (brown) and *tagar* tree wood (yellow). Varying the proportions and adding other ingredients can produce a tremendous range of colors.

songket: Handwoven cotton or silk with weft brocade of gold or silver yarns.

tapa: Coarse cloth made in the Pacific islands from the pounded inner bark of the paper mulberry or other trees.

uchishiki: Patchwork altar cloth used in Buddhist temples and made by taking apart a single kimono and reassembling the pieces into a square so that all the fabric is used.

ulap doyo: Type of resist-dyed weaving from Indonesia's East Kalimantan, made from thread produced from fiber extracted from leaves of the *doyo* plant, a wild swamp grass.

wisteria cloth: Rough-textured fabric made from the fibers of wisteria vines.

I N D E X

Amish people, quilts of the 8, 24, 25–27, 29, 33, 34–37, 115

antique cloth 16–17, 38–45

Arai, Jun'ichi, fabrics by 8, 10, 20–21, 28, 46–47, 50–51, 54–55, 58–59, 60, 62–63, 117, 118, 119

bamboo, dyeing with 1, 2–3, 4–5, 9, 10, 11, 14–15, 18–19, 62–65, 68–69, 70–71, 72, 73, 74–77, 78–81, 82–85, 86–89, 106–9, 110–13, 114, 120, 121–22, 123, 124

bias tape 56, 61, 77, 81, 89, 100–101, 104–5, 108–9, 112–13, 118

braiding 68–69, 74, 121–22, 123

cord piping 20–21, 50–53, 58–61, 76–77, 100–101, 104–5, 108–9, 112–13, 118–19

Embossed Quilt 1, 4, 5, 8, 9, 14–15, 74–75, 76–77, 86–89, 124

Engineered Quilt 33, 66, 94–97, 98–101

flower arranging 28, 29

free-motion machine quilting 10, 50–53, 54–57, 94–97, 102–5, 117

funzoe (quilted rag patchwork surplice) 31–32

Grass House Studio 14–15, 22–23, 29, 66–69, 70–73, 74–75, 92, 94–95, 98

indigo 90, 91, 92, 93

Irish Chain 46–49

kembangan 28, 29

kesa (priest's surplice) 31–32

kimono 27–28, 30 geometric construction of 31–33, 94

Kuba velvet 118

Log Cabin 20–21, 41, 58–61, 62–65, 86–89, 119, 120

mandala 16–17, 38–45, 116

melt-off 50–53, 54–57, 59, 117, 118

Mennonite people, quilts of the 8, 25, 27–29

Nine Patch 41

Optical Quilt 10–11, 62–65, 100–101, 114, 120

pintuck work 11, 82–85

sarong (sarung tapis) 55, 56, 94

selendang (traditional Indonesian shawl) 8, 28, 29

Seminole patchwork 105, 125

soga (Indonesian natural dye) 12–13, 62–63, 90, 91, 92, 98, 99

synthetic fibers 7, 8, 10–11, 20–21, 46–49, 50–53, 54–57, 58–61, 62–65, 117, 118, 119, 120

tea ceremony 28, 29, 40

uchishiki (patchwork Buddhist altar cloth) 30, 32–33

weaving 74, 78–81, 94–97, 98–101, 123